Salisbury
A Walk in the Close

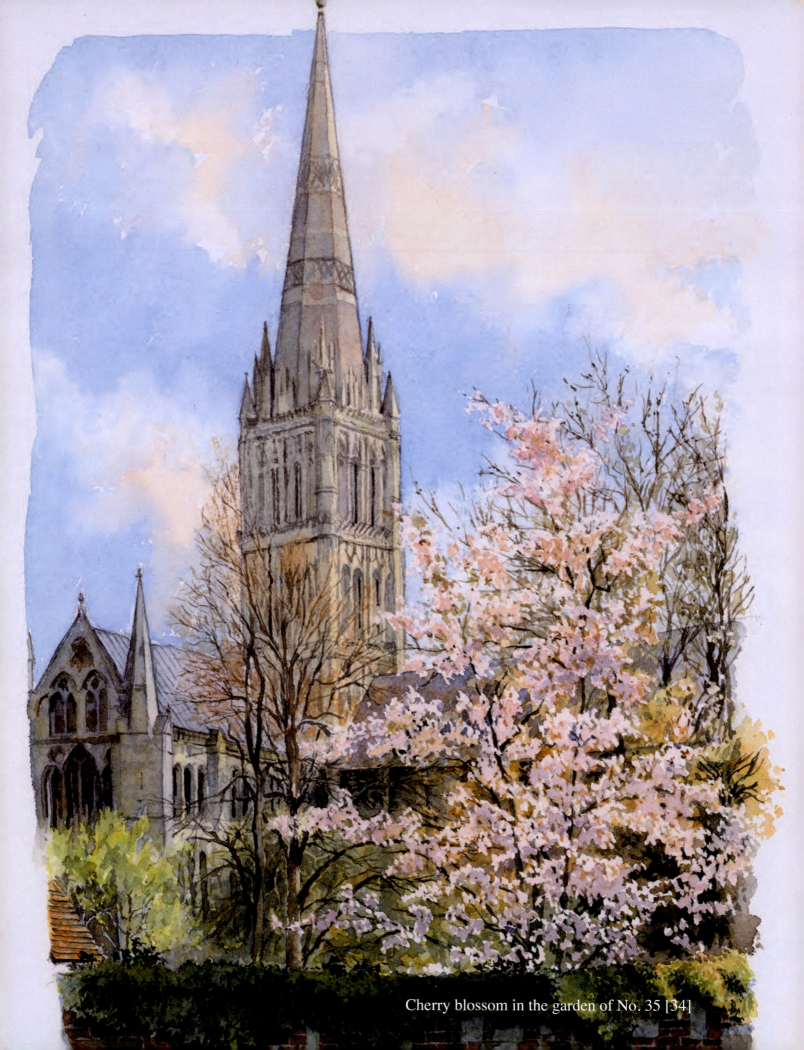

Cherry blossom in the garden of No. 35 [34]

Salisbury
A Walk in the Close

Sue Finniss

with architectural descriptions by
John Elliott

Spire Books Ltd
PO Box 2336, Reading RG4 5WJ
www.spirebooks.com

Spire Books Ltd
PO Box 2336, Reading RG4 5WJ
www.spirebooks.com

Jacket: Salisbury Cathedral from Choristers' Green [39]

CONTENTS

Each painting has a number which is shown in square brackets [9] and cross refers to the map on pages 6 & 7.

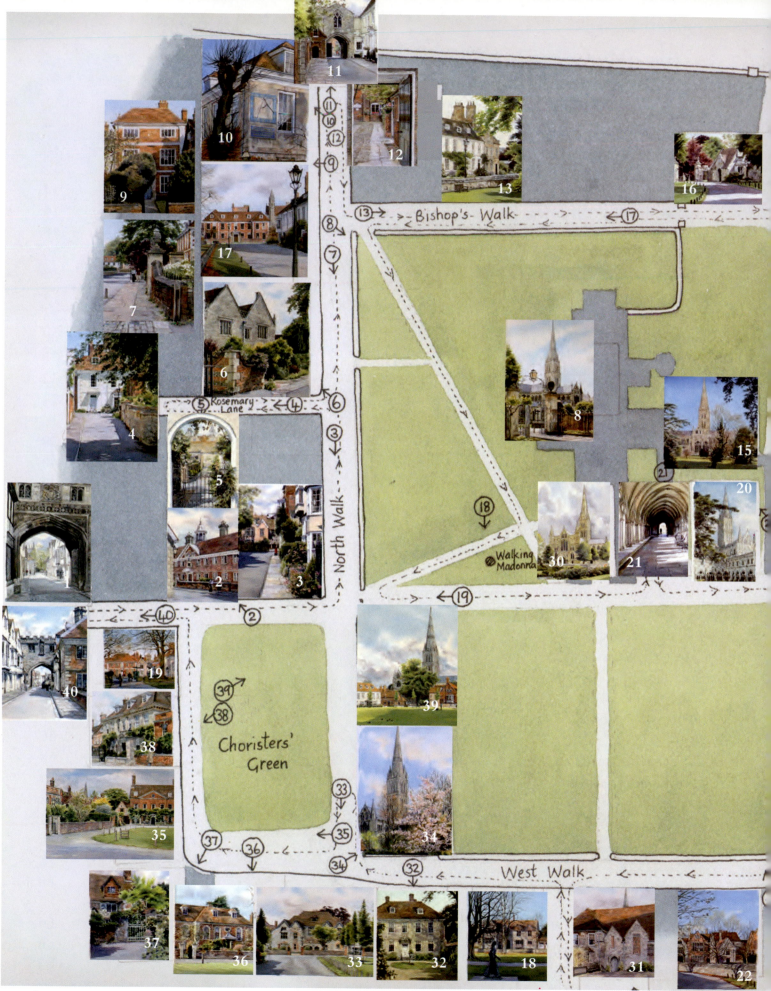

Bishop's Walk

North Walk

Rosemary Lane

Walking Madonna

Choristers'
Green

West Walk

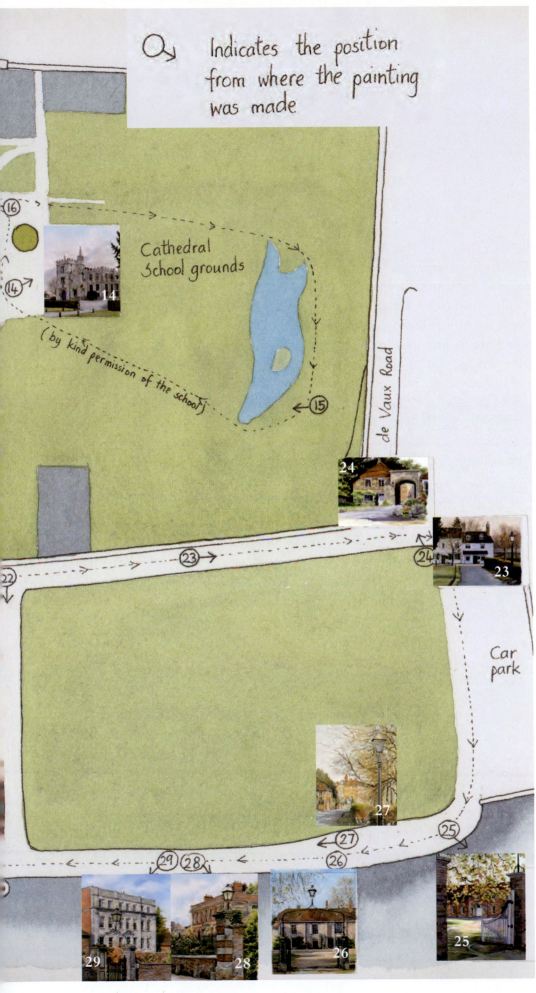

Indicates the position from where the painting was made

Cathedral School grounds

(by kind permission of the school)

de Vaux Road

Car park

[1] North Gate
[2] Matrons' College
[3] North Walk
[4] Loders
[5] Gateway in Rosemary Lane
[6] Aula le Stage
[7] North Walk looking west
[8] The Cathedral from Sarum College
[9] No 17 the Close
[10] Malmesbury House
[11] St Ann's Gate
[12] Bishop Wordsworth's School
[13] Nos 6 & 7 the Close
[14] Old Bishop's Palace (the Cathedral School)
[15] John Constable's view
[16] Gatekeeper's Lodge
[17] Sarum College
[18] Walking Madonna & North Canonry
[19] A View to the north
[20] Tower & spire from the cloisters
[21] Cloisters
[22] King's House
[23] Nos 72 & 73 the Close
[24] Harnham Gate
[25] South Canonry
[26] Leadenhall
[27] The Close
[28] Walton Canonry
[29] Myles Place
[30] The Cathedral from the west
[31] Medieval Hall
[32] Arundells, No. 59
[33] The Wardrobe
[34] Cherry Blossom in the garden of No. 35
[35] Corner of Choristers' Green
[36] Wren Hall
[37] 56a & b, Hemingsby
[38] Mompesson House
[39] Cathedral from Choristers' Green
[40] North Gate exit

This map is not to scale and does not include all the splendid buildings that are in the Close.

Despite living in or near Salisbury for my whole life, I have never tired of the beauty of the cathedral and the surrounding Close. The sunlight catching the textures of the multicoloured brickwork and stone, the long shadows cast by the majestic trees, combined with the elegance and grace of the architecture, have, for many years, all motivated me to attempt to capture the images in watercolour.

I think I was twelve when I did my first drawing of the Close for a childrens' competition. I trained to be a teacher under the shadow of the spire at the college of Sarum St Michael and sang with a chamber choir, The Farrant Singers, that still rehearse in the Cathedral School. The magnificent image of the floodlit cathedral at the end of the rehearsals never failed to impress me.

In 2008, when I began to paint this collection, we were all celebrating the 750th anniversary of the cathedral's consecration. This book is my personal celebration of the cathedral and its environs which have always been such a presence in my life.

I should add that the paintings are not intended to be photographic representations and I have used artist's license to occasionally rearrange nature as seemed most appropriate.

I owe a huge debt of gratitude to John Elliott for providing the architectural and historical notes that accompany the paintings and to those at Spire Books who have made it possible for me to realise a dream.

Finally, this book is dedicated to my parents, Margaret and George Norris.

Sue Finniss
February 2009

The cathedral from Sarum College [8]

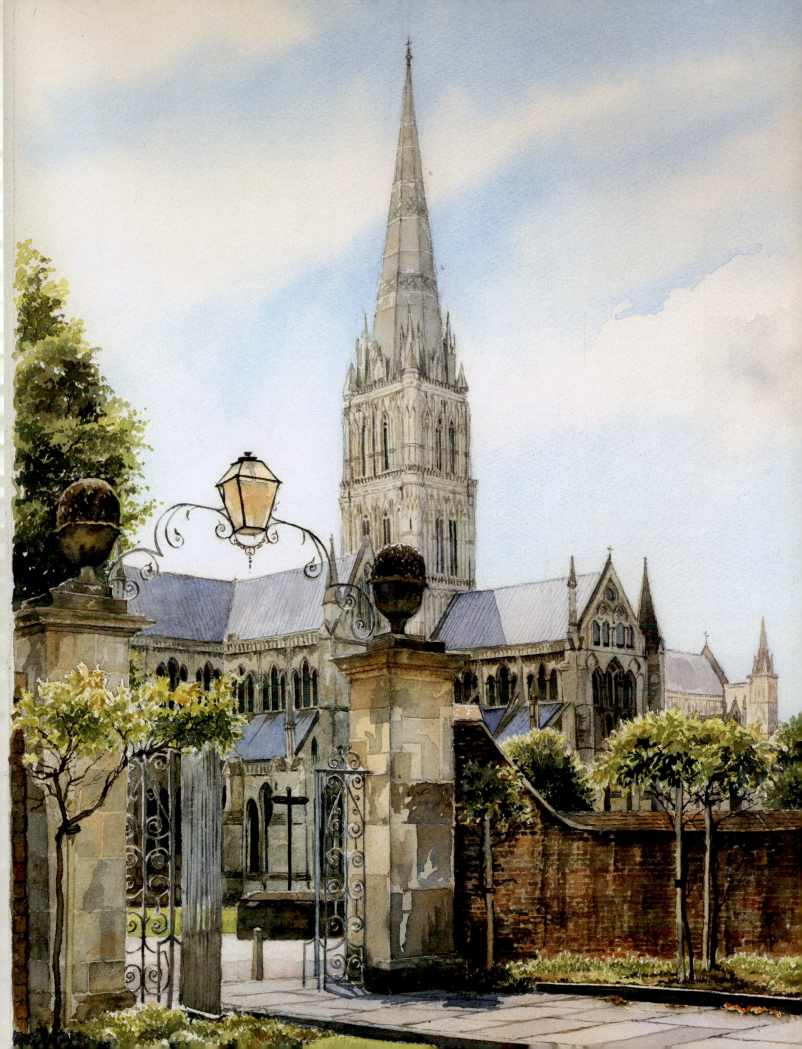

Introduction

The story of Salisbury begins at Sherborne, where in 705 the King of Wessex created a new bishopric, and appointed Aldhelm as bishop, to oversee the western half of his kingdom. Sherborne Abbey became a Benedictine abbey in 998 and Ramsbury was hived off in 909 with responsibility for Wiltshire and Berkshire. Then in 1075 William the Conquerer's Council of London decreed that cathedrals and their associated buildings should henceforth be located in fortified towns, and that the cathedral for the area stretching from Berkshire to Cornwall should be based on a hill at Sarisberie, or Old Sarum as we know it today.

Old Sarum had been an Iron Age hill-fort and a Roman settlement before it was adopted by the Normans and became a major castle site. After the diocese began to relocate from Sherborne a new cathedral was built there (1078-99, consecrated in 1092) and the religious shared the site with the military and their castle. The cathedral was extended and rebuilt under Bishop Roger before, in 1219, the then bishop, Richard Poore, decided to move the cathedral complex to a completely fresh site in the valley below. This would mean that they could build anew with space, rather than continue to exist on a restricted site.

The Pope gave permission for the move in 1219, the foundation stone for the new cathedral was laid by Bishop Poore in 1220, and work started on the eastern end. Three eastern altars were consecrated in 1225. Work continued and sufficient progress had been made for the cathedral to be consecrated in 1258, in the presence of Henry III and dedicated to the Blessed Virgin Mary, though the nave roof was not leaded till 1266. A huge bell-tower was erected at the same time to the north of the cathedral and this remained there until James Wyatt removed it in 1789. The cloisters and chapter house were constructed between 1240-66.

As originally designed the cathedral only had a short stumpy tower and no spire. However, a decision was soon made to add a double-storey tower and a spire – all in stone – and this work started in about 1310 and continued until 1330, making Salisbury Cathedral one of the most striking of all the medieval cathedrals.

While the cathedral was being built the land around what is now the Close was divided into plots and given to the canons so that they could start to build residences – 'fair houses of stone'. A surrounding wall followed to separate the cathedral space from the new city of Sarum that was developing rapidly to the north of the cathedral.

There have been many restoration campaigns in the last 750 years. The tower and spire caused problems, and strainer arches plus complex ironwork have been added, especially inside the tower, to give the whole structure greater stability. Later, in the 18th century, between 1789 and 1792, James Wyatt controversially reordered the interior and the fabric of the building, removed the bell-tower and landscaped the Close, removing the grave stones to produce the wide open spaces we see today.

The cathedral is the resting place of Bishop, later St Osmund, a reforming bishop at Old Sarum who laid the basis for a form of ecclesiastical management and liturgy known as the Sarum Rite.

The building is of stone from Tisbury, Chilmark and Purbeck and is built in the Early English style, though the tower and spire show traces of an evolution to Decorated Gothic. The building is unique in its unity of style.

The cathedral from Choristers' Green [39]

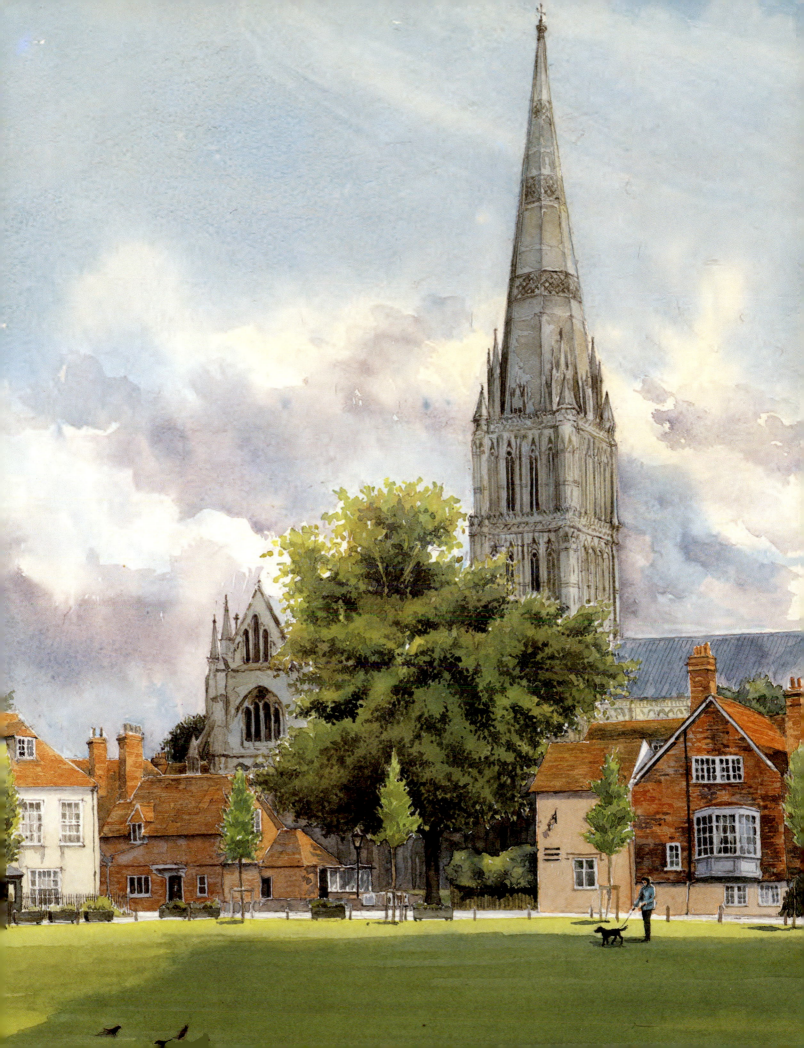

North Gate [1]

As its name implies, this gateway is at the north of the Close and provides two-way vehicular and pedestrian access between the Close and Salisbury High Street. The gate is closed each evening and remains closed until the following morning.

This is the main entrance to the Close and leads directly from the High Street of Salisbury, or New Sarum as the town was originally called. The gate was probably built between 1327 and 1342, possibly replacing an earlier temporary gateway.

The current structure is largely original and is built of a mixture of rubble stone and coursed ashlar. The north face was rebuilt in the latter part of the 15th century and included a portcullis which has since been removed. In the 17th century the Stuart royal arms were added on the north side and a statue of a Stuart king on the south, though the latter was replaced by the effigy of Edward VII in 1902.

The gate would have been manned by a porter, and perhaps other staff, who were located in no. 49 above the gate and in no. 48 which is on the eastern side of the gateway.

The houses to the west of the road are nos 50, 51 and 52 the Close. Those nearest to the gateway originated in the 15th century - probably between 1404 and 1431 - as two-storey, timber-framed shops. In the 16th century merchants, a goldsmith and a joiner traded from here. After 1608 the shops were restored and the buildings altered to also provide accommodation above. They were converted to cottages in the 19th century.

The furthest building on the right - no. 52 - was formerly two shops which belonged to the lay vicars and were built in the 15th and 16th centuries.

The half-timbering used in medieval houses is still visible in the facades, especially the jettying which enabled the upper floors to project over the ground floor.

Today some of the buildings are used as offices and the rest as dwellings.

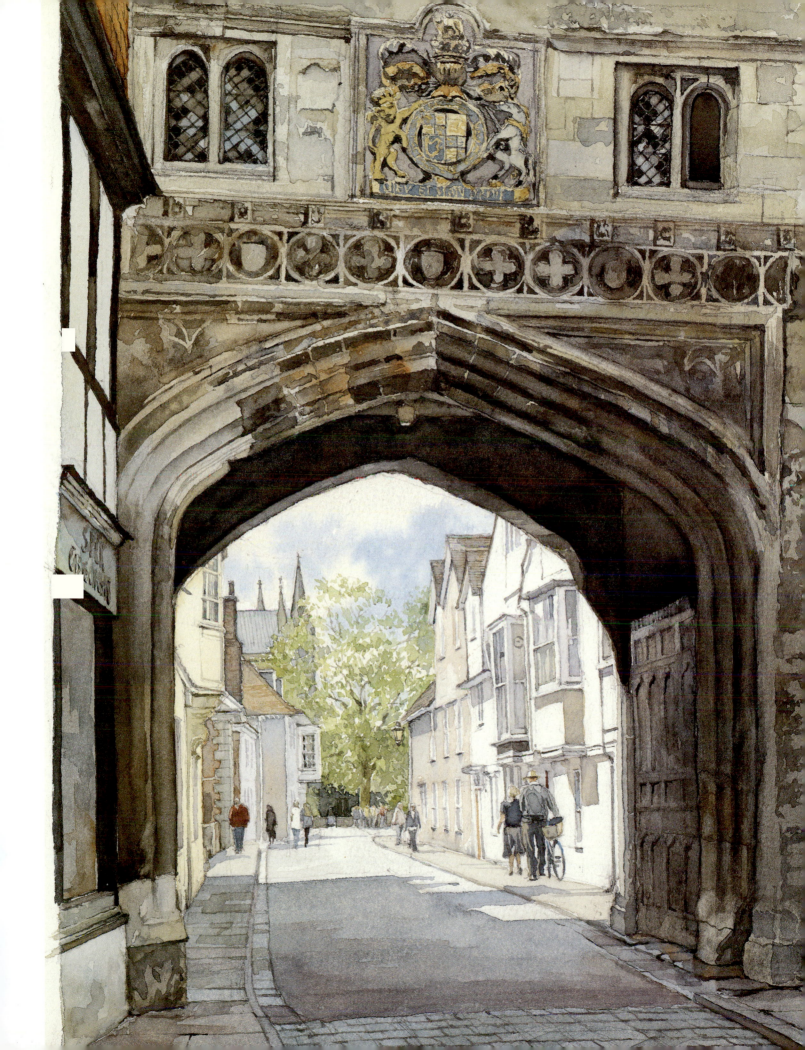

Matrons' College [2]

Located just inside the North Gate on the eastern side of the roadway. After the cathedral, this is probably the most viewed building in the Close. The eight residences are privately occupied and are not open to the public.

This large and impressive building was erected in 1682 as almshouses and was paid for by Bishop Seth Ward, founder member of the Royal Society and one of Salisbury's most influential bishops. It was intended as accommodation for widows of the clergy and continues to fulfil a similar need.

The building, including removal of what was there before, cost £5,123, including an endowment. Originally there were ten separate dwellings within the building, but this was reduced to eight in 1870.

The building work was undertaken by Thomas Glover from Harnham, and it is suggested that Christopher Wren had some involvement. Certainly the style is one with which he would have been comfortable, though the building lacks some of the refinement he would probably have introduced had he been in charge.

T.H. Wyatt made significant changes in 1870 when the interior was virtually rebuilt to provide better accommodation for eight residents rather than the original ten, giving a sitting room and kitchen downstairs and two bedrooms and bathroom above.

The western facade is typical of the late 17th century, with its attractive mix of brick and stone. Above the doorway Seth Ward's cartouche announces:

<div align="center">

COLLEGIUM HOC MATRONARUM

Do Co Mo

HUMILLIME DEDICAVIT

SETHUS EPISCOPUS SARUM

ANNO DOMINI

MDCLXXXII

</div>

Above that, in the pediment, there is a cartouche-of-arms of Charles II flanked by scrolls.

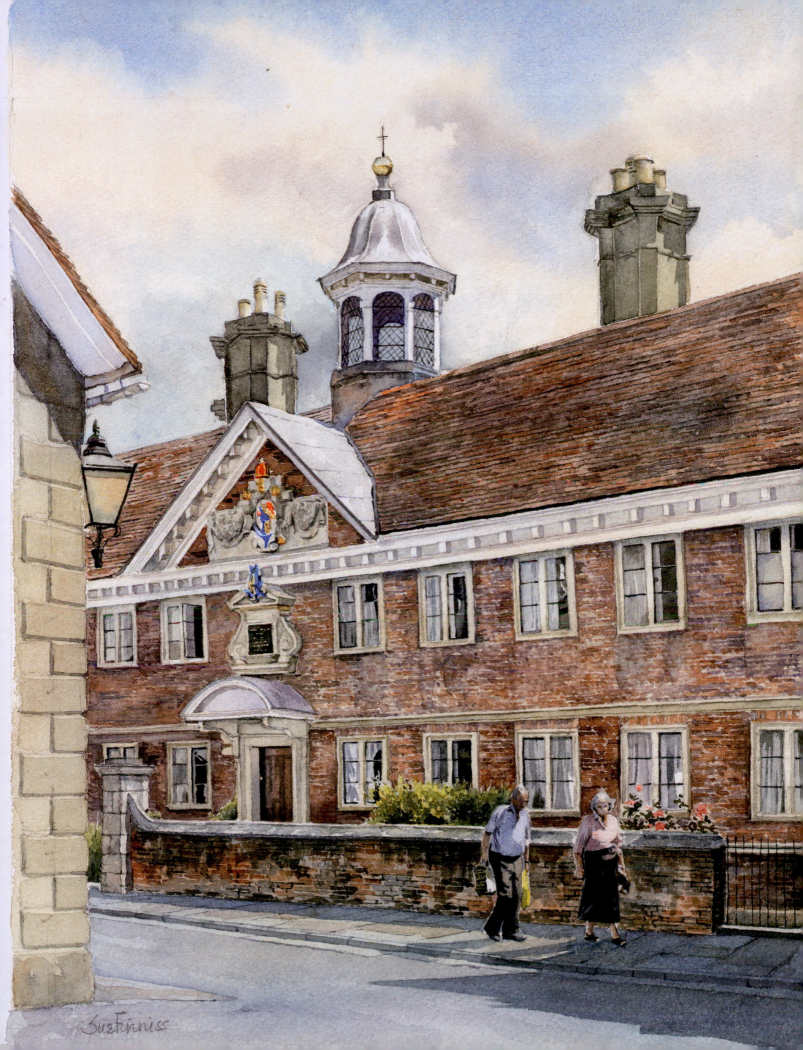

North Walk [3]

This view looks towards the west along the North Walk. The entrance through the North Gate is on the right beyond the post box.

The pink coloured house in this painting is the end facade of what was originally a substantial single house which has since been subdivided.

A house has existed on this site since as early as 1571, though there has been much alteration and rebuilding since then, especially in the 18th and 19th centuries. The south elevation, which is just beyond the left-hand side of the picture, marks the site of the graveyard wall. If viewed as a whole the original building is a wonderful mix of coloured rendering, brick, stone and tile.

The buildings on the right provide an interesting blend of styles and facades. Again, as elsewhere in the Close, the underlying remains of a medieval structure have subsequently been rebuilt and refaced in a later style.

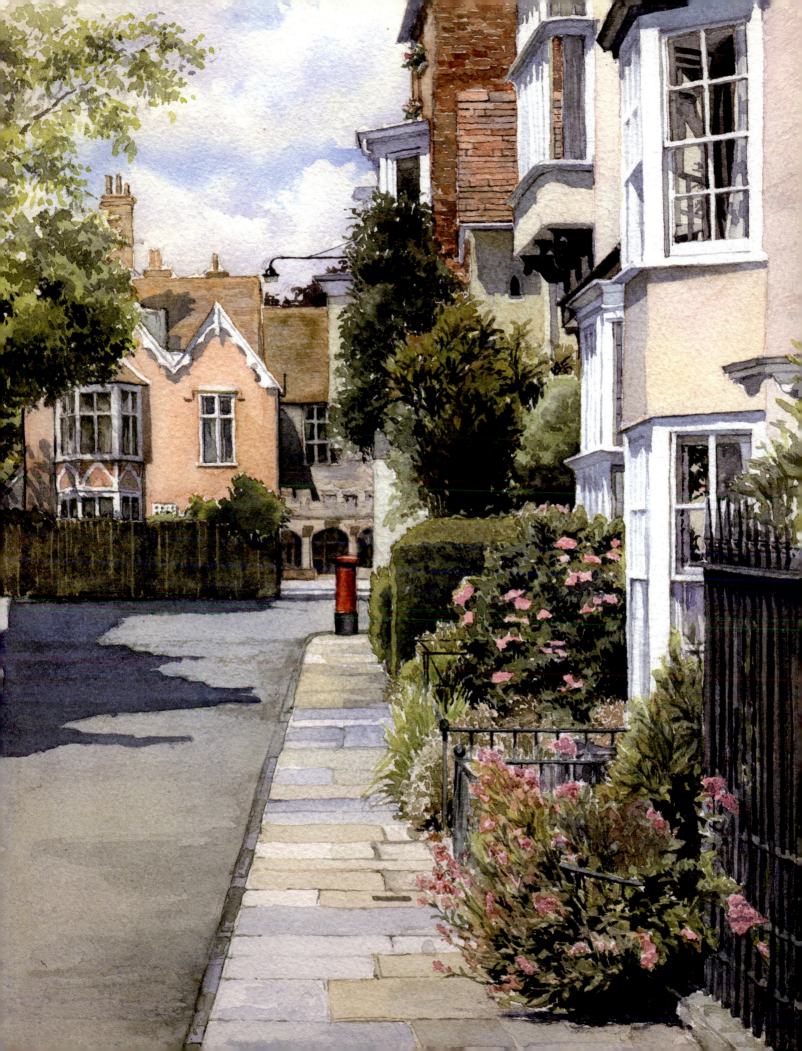

Loders [4]

This house is at the bottom of Rosemary Lane which is off the North Walk.

The name Loders comes from a medieval prebendal mansion which stood on, or near, here.

Later the plot became a garden, until, between 1705-7, a house was built on the site for a Mr Ryder. It is of two parts; the front is square with two storeys, an attic and cellar, very Georgian in appearance. Behind this there are a range of rooms that connect with the Close wall.

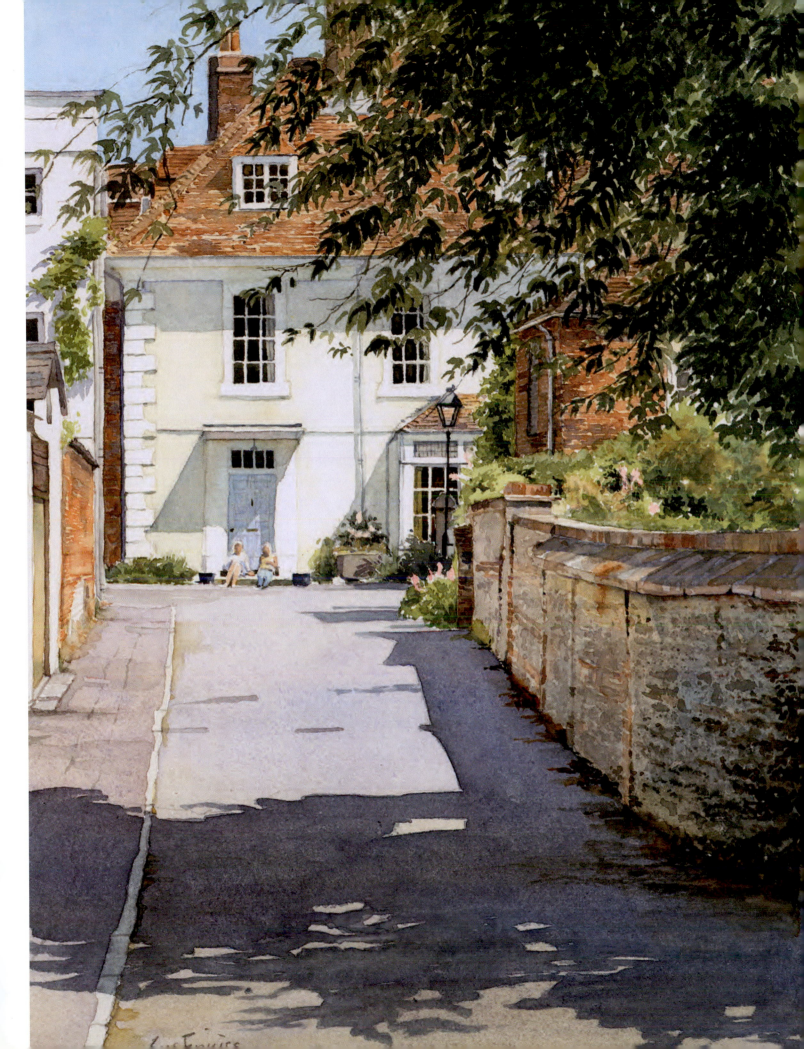

Gateway in Rosemary Lane [5]

Rather surprisingly this quiet backwater within the Close has connections with the reappearance of Roman Catholicism in Salisbury.

After the Reformation Roman Catholicism never completely died out. By the mid-18th century there were small pockets of adherents at Odstock and Wardour. There was also a small group in Salisbury from as early as 1765 when Mass was said in the house of Mrs Arundell which was at the end of Rosemary Lane. After that the Mass Centre moved out of the Close and into the attic of a house in St Thomas's Square; briefly back into the Close to the Porter's Lodge by the North Gate; then into the city again to the Chapel House on Brown Street from 1803, before moving to the upper floor of a building in St Martin's Lane at the top of St Ann's Street. The first permanent post-Reformation Roman Catholic church in Salisbury was built in 1847–8 to the designs of A. W. N. Pugin and is located on Exeter Street, immediately outside the Cathedral Close.

Pugin had lived on the outskirts of Salisbury between 1835 and 1837 and converted to Roman Catholicism in 1835 while living there. He had always seen the cathedral as 'both an inspiration and an agony'; an inspiration because it had been 'the supreme work of the Catholic mind', and an agony because much of its wonder 'had been shattered by reforming zeal'. The church dedicated to St Osmund was intended to be an 'inexpensive miniature' which would 'replace the Cathedral as a home for the Mass'.

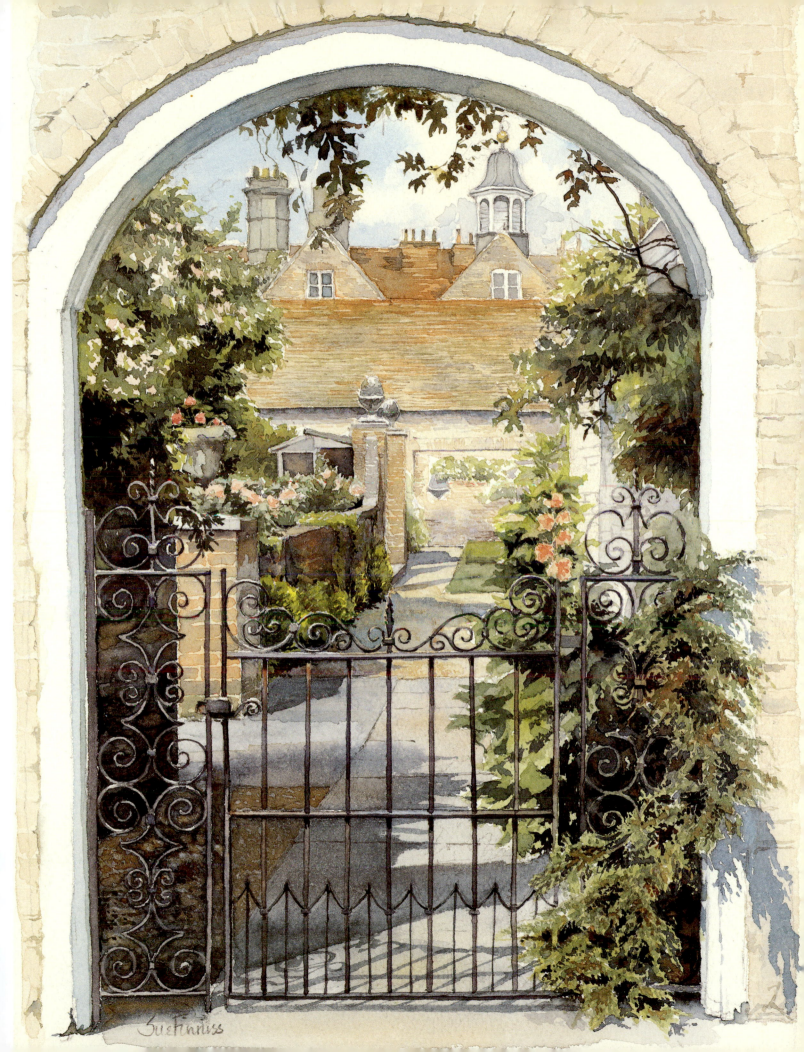

Sue Finniss

Aula le Stage [6]

This is another fine house, though today sub-divided, while retaining many elements from its previous incarnation as one of the medieval canon's houses. Stylistically the facade is Elizabethan with a fine flint front which includes two dominant gables and mullion windows.

The first building on the site originated in the 13th century but most probably contained little more than a parlour and chapel. A tower was added and after 1440 it was called Aula le Stage, meaning tower house. A new hall and outbuildings were erected in the 14th century and the accommodation was extended twice in the 15th century. A major restoration followed in the Elizabethan period, when the new facade was added as were internal ceilings, supposedly resembling those at Hampton Court Palace, the Close at this time becoming a desirable residence for wealthy citizens.

The house ceased to be a canonry in 1850 and was subdivided in 1972.

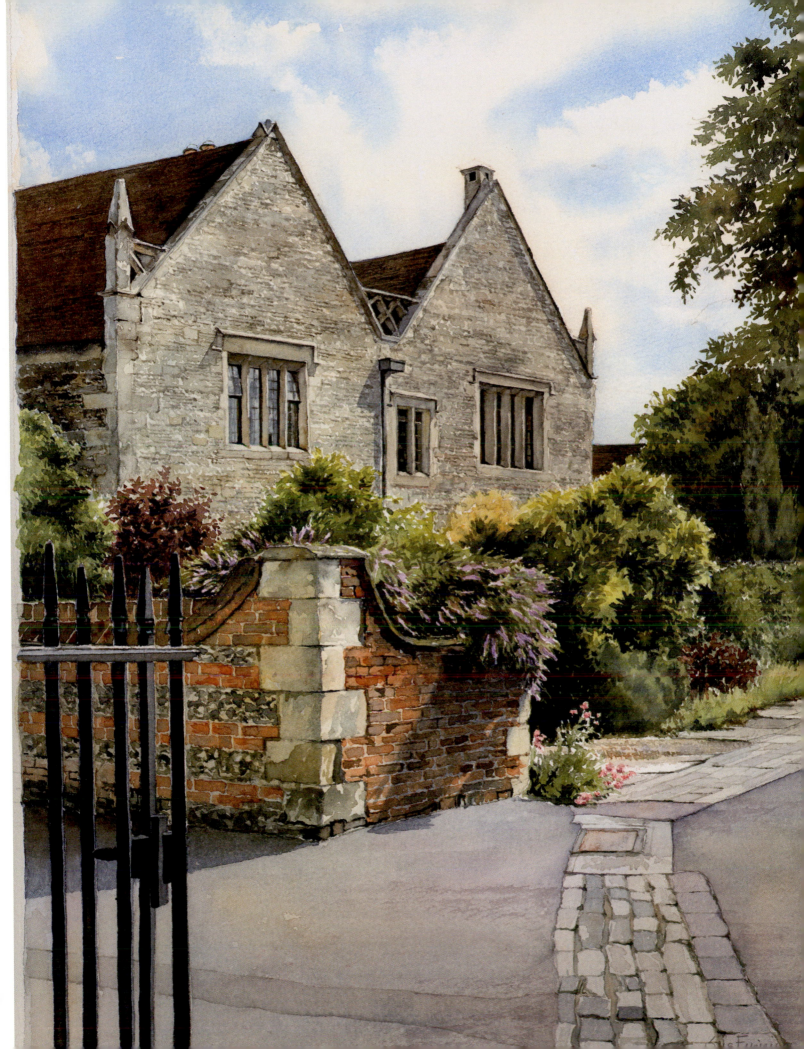

North Walk looking west [7]

This view is taken from just outside Sarum College and looks west. The buildings in the distance are those almost opposite the entrance from the North Gate.

The cathedral was originally planned without the large tower and spire. To enable bells to be rung a separate bell tower, or campanile, was erected in the Close, just to the north of the cathedral.

The bell tower was there by 1266 and remained until 1789 when it was swept away as part of the reordering of the Close. It would have been the tallest building in the Close apart from the cathedral.

Bishop Shute Barrington arrived in Salisbury in 1782. He disliked much that existed, especially the chantry chapels, the remnants of medieval stained glass, the dilapidated bell tower and the graveyard which was in a depressed state and dominated what are today the open grassed areas of the Close. Barrington employed James Wyatt to sweep away most of these unsightly remnants of the past and to give the Close a new open feel. The bell tower was demolished – though its footprint can still be seen in mid-summer when viewed from the tower – the gravestones were removed and the graveyard flattened and grassed. While many have complained of the supposed brutality of these changes, they have provided Salisbury with a Close that is unparalleled for openness and elegance.

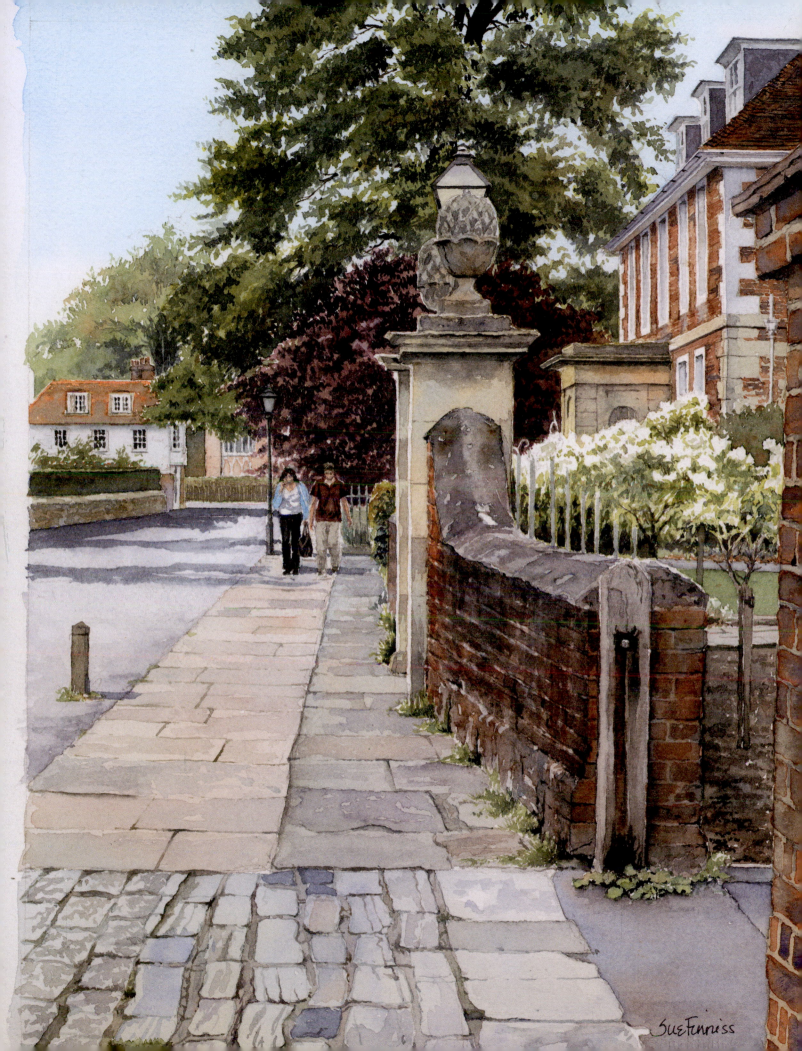

No 17 the Close [9]

This fine house is located on the northern side of the North Walk midway between Sarum College and St Ann's Gate.

This is a house from the early 17th century which has been little altered. It almost certainly stands on the site of an earlier dwelling.

Built of brick with stone window mullions, it is mostly of two storeys with a third attic storey above. On the ground floor there is a parlour and drawing room with kitchen and associated rooms behind. On the first floor one large dining room stretched across the front with bedrooms behind and on the top floor.

Dr Turberville, an internationally renowned eye surgeon/oculist lived here in the late 17th century and his reputation brought 'multitudes to him from all parts of this and the neighbouring kingdoms and even from America'.

In the 19th century this was the home of W.E. Tower, the stained glass manufacturer. Tower was in partnership with C.E. Kempe who used the wheatsheaf as his symbol. W.E. Tower used a depiction of a small black tower. One or both of these symbols will often be found in Kempe windows.

The company was very successful and became one of the major British manufacturers of stained glass. There is some Kempe glass in the lecture hall of the Salisbury & South Wiltshire Museum.

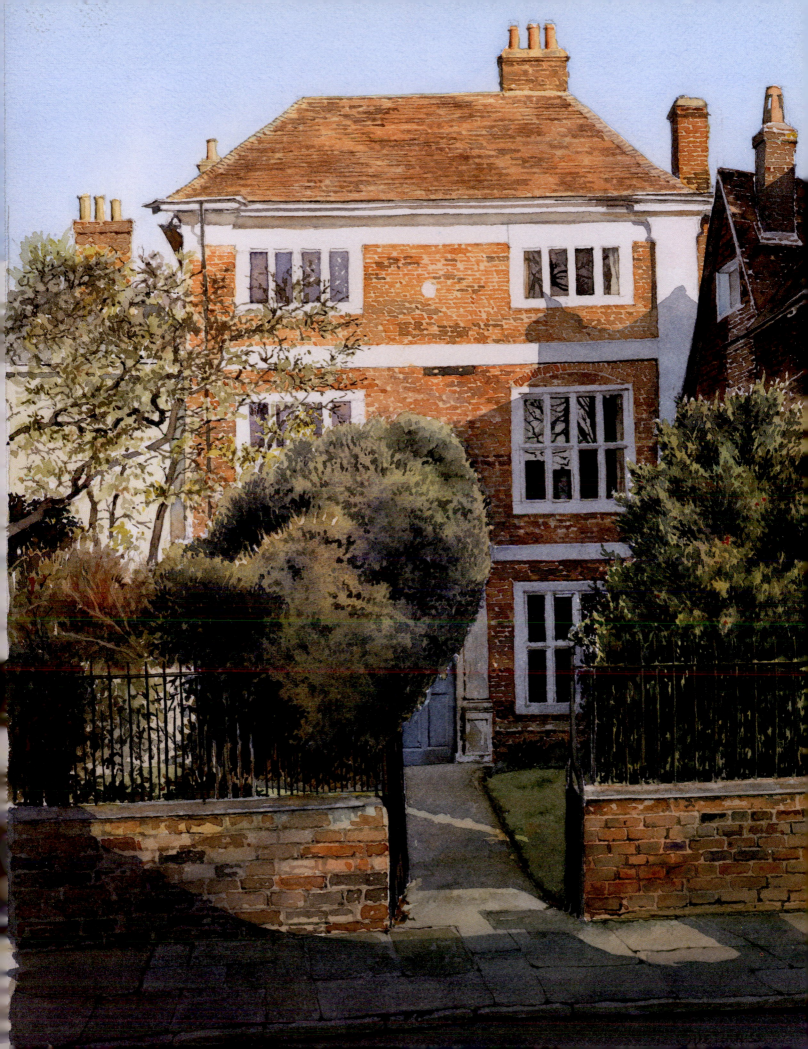

Malmesbury House [10]

This elegant house is located at the eastern end of the North Walk adjacent to St Ann's Gate. It is a private residence and not usually open to visitors.

In 1703 James Harris II acquired the lease on this site and in 1705 started rebuilding an early 17th-century house, itself on the site of small medieval dwellings, so creating much of what we see today. Work was completed by 1719 and a seven-bayed, two-storeyed building emerged with a grand facade. This work was continued by his son, also called James, who was responsible for much of the interior reordering. Inside, the decoration is exceptional. Much dates from 1745-9, but there is also some excellent Rococo work and examples of the earliest phase of the Gothic Revival.

James Harris III achieved national fame. He wrote a study of philosophy which he titled *Hermes*, was a close friend of Henry Fielding and knew David Garrick and Dr Johnson. He became an MP and held posts at the Treasury and Admiralty before becoming secretary and comptroller of the queen's household.

Harris was a patron of the arts and created in the city 'the finest society outside London', with concerts in the music room above the adjoining St Ann's Gate which he also owned.

The sundial is dated 1749. and there are panels on the exterior wall which commemorate the death of 'worthy' Protestants in the religious battles that accompanied the Reformation.

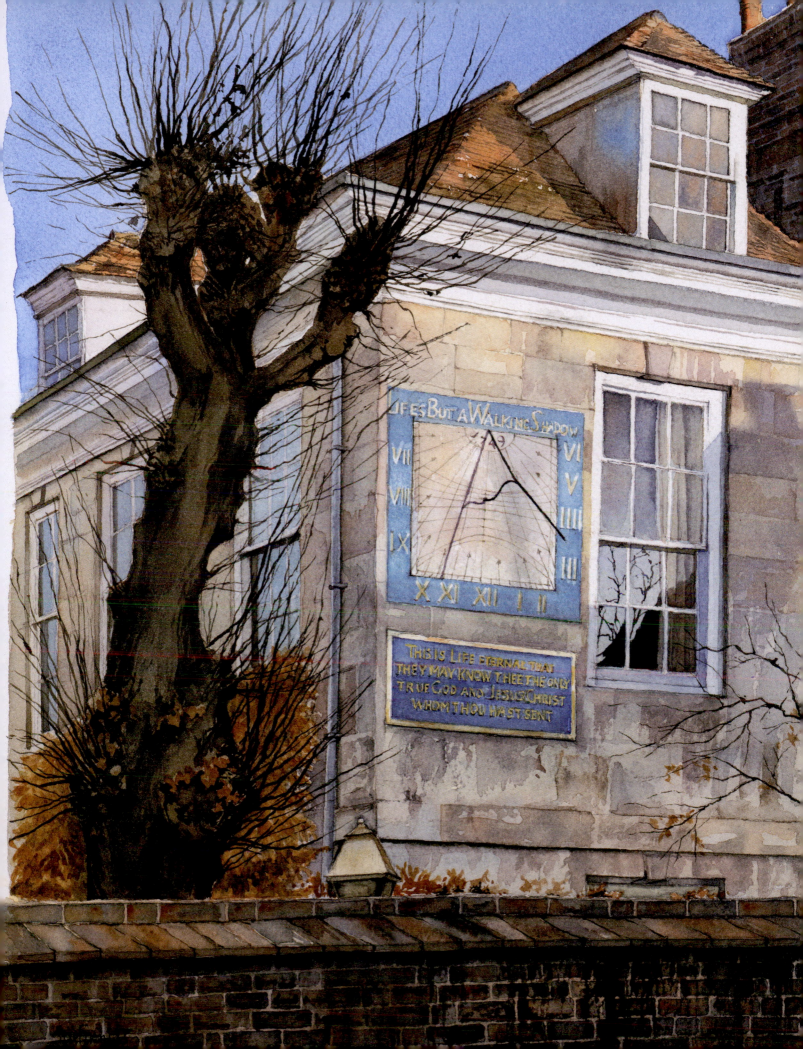

St Ann's Gate [11]

This is located on the eastern side of the Close, at the end of the North Walk and provides pedestrian access between the Close and the Exeter Street and St John Street junction. The gateway is closed each night.

A gate existed here as early as 1293. The current structure was probably built in stages, and largely completed and in use by 1354 along with a chapel which existed in the rooms above. The chapel was dedicated to St Ann and the Blessed Virgin Mary, and a special indulgence was available to those who visited. It appears to have remained until the Reformation when the upstairs was converted to secular use.

In 1611 ownership of the gatehouse passed to the vicars and from about 1640 it was held as an adjunct to Malmesbury House. In the 18th century the chapel was used as a concert hall and theatre and James Harris's most famous visitor, Handel, is reputed to have appeared there.

The two-storey structure is of ashlar stone and the style mostly Decorated Gothic, though with some variations which suggest a gradual development. The roofs are of lead. Today the chapel is an architect's office.

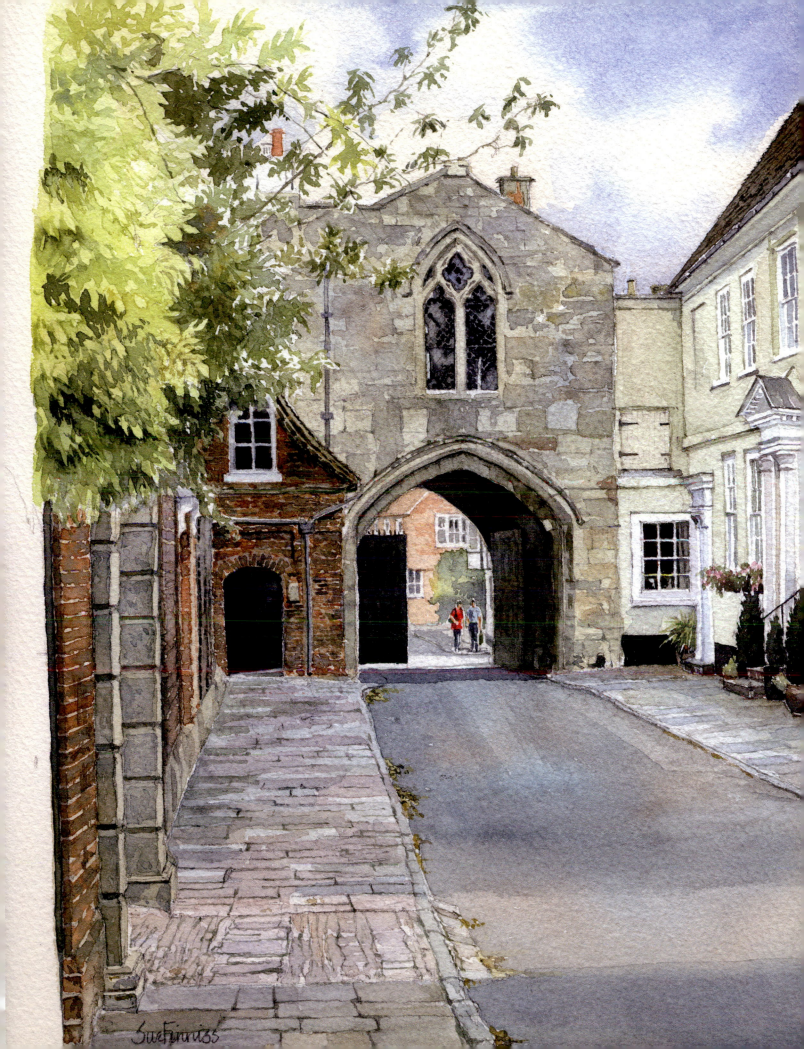

Sue Firniss

Bishop Wordsworth's School [12]

This gateway is located on the southern side of the eastern part of the North Walk and leads to the Bishop Wordsworth's School.

Bishop Wordsworth's School was founded in 1890 by John Wordsworth, the bishop of Salisbury. His intention was that the school should offer a high-quality education to boys and today there are nearly 900 pupils. Entrance to the grammar school is by examination at age 11. The school was co-educational for 25 years in the early 20th century but eventually a separate girls' grammar school was built in the northern part of Salisbury.

By the doorway there is a blue plaque which commemorates writer William Golding (1911-93). Golding, the son of a schoolmaster and suffragette, was born in Cornwall and educated at Marlborough Grammar School and Brasenose College, Oxford. He won the Nobel prize for literature in 1983 and was a teacher and staff member at Bishop Wordsworth's School from 1946 until 1961.

He joined the Royal Navy in 1940 and spent six years afloat. He saw action against battleships (at the sinking of the Bismarck), submarines and aircraft. He finished as lieutenant in command of a rocket ship. He was present off the French coast for the D-Day invasion.

After the war he taught English and religious education at Bishop Wordsworth's School but he was a master of many subjects including naval history, music, philosophy and Greek. Known affectionately as "Scruff", his first published novel, *Lord of the Flies*, included some of the character traits of the boys he taught. This was published in 1954 and filmed by Peter Brook in 1963. He worked in the shadow of the cathedral spire and this is reflected in his powerful book, *The Spire,* of 1964.

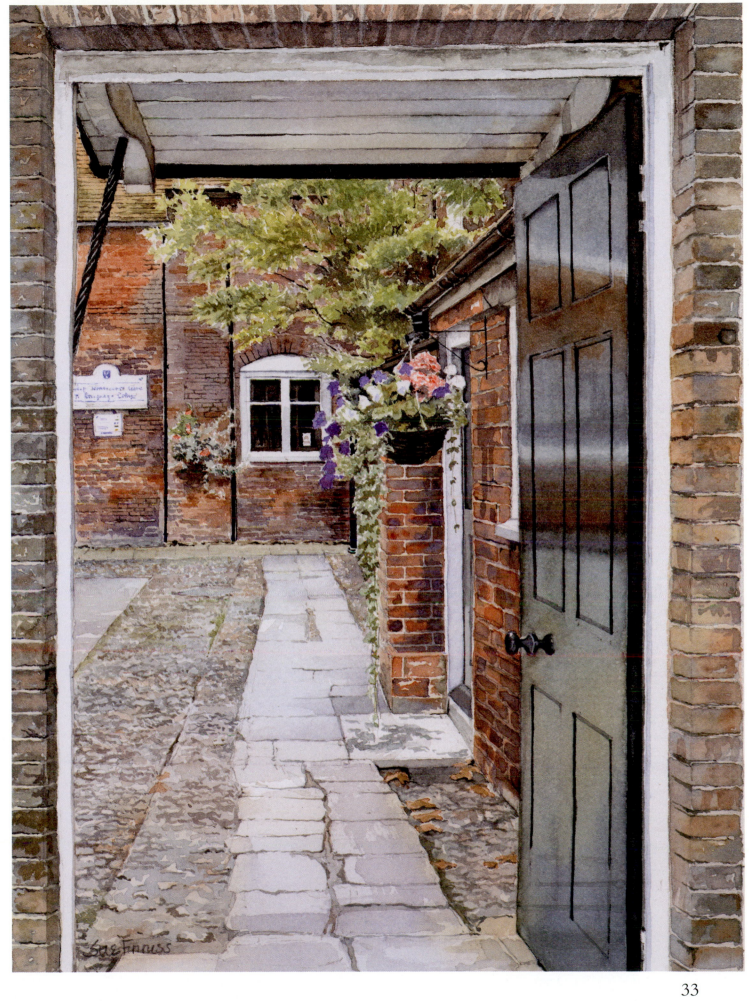

Nos 6 & 7, The Close [13]

These houses are on Bishop's Walk at the eastern side of the Close. They form a small complex of buildings which house the Chapter Office and Deanery.

This complex of buildings was reordered during the 19th century from a 17th-century house which itself stood on the site of a medieval canonry. The two buildings were separated around 1850.

No 6 was built *c.* 1675, is of brick, has two storeys and mullioned windows.

No 7 - now subdivided into 7a and 7b and part of which is the Deanery - was built before 1660 and formed part of a complex of stables and coach-houses with accommodation above. It was much altered in appearance by the addition of sash windows, probably around 1817. The interior was also altered during the 18th and 19th centuries.

The Deanery is a perfect example of high taste during the latter part of the 18th and the start of the 19th century.

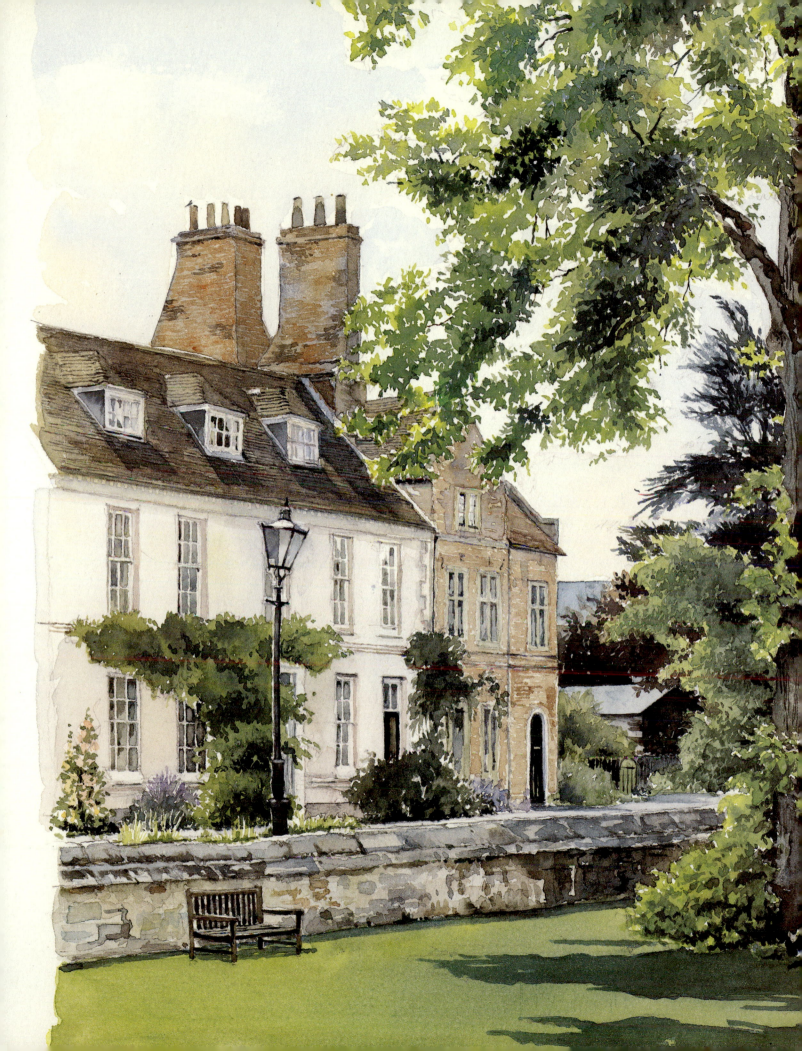

Old Bishop's Palace (The Cathedral School) [14]

Located in the far south-east corner of the Close at the southern end of the Bishop's Walk. It is now the Cathedral School.

This is one of the most important buildings in the Close. It was the Bishop's Palace for many centuries before becoming the Cathedral School in 1947.

Part of the building dates from Bishop Poore's palace of 1220. Other parts are from Bishop Beauchamp's additions c.1460-1500, while yet more was added by Bishop Seth Ward in 1670-4. Further additions and changes have followed at regular intervals. Its scale, style and elegance says much about the status of a medieval bishop.

The oldest remains are at the western end, especially the 13th-century vaulted undercroft. Particularly notable is the Great Drawing Room which probably dates from the 1740s and Bishop Sherlock's tenure. It is decorated with a frieze, heads and garlands, a coved ceiling and giant Venetian windows. The chapel is from the 15th century.

When planning the cathedral and Close, the bishop was allocated a prime and large site for the erection of his palace. The dean and more senior canons were allocated plots on the western side of the Close, fourteen in all, where they were expected to build a house suitable for themselves and their vicars choral who would deputise for them at the cathedral services, plus any other staff they may have. The lesser canons were allocated somewhat less prestigious plots off the North Walk and Bishop's Walk.

By 1222 a number of the canons had not started building and it seems that the costs deterred many. Some only resided in Salisbury for limited periods. By the 14th century many of the houses had come to be owned by the Dean and Chapter rather than by individual canons, after which they were allocated according to seniority.

The costs of living in the Close were always substantial and gradually some of the houses passed into secular leased occupancy. Today most are still owned by the Dean and Chapter, though the majority of the occupants of the Close are not clergy.

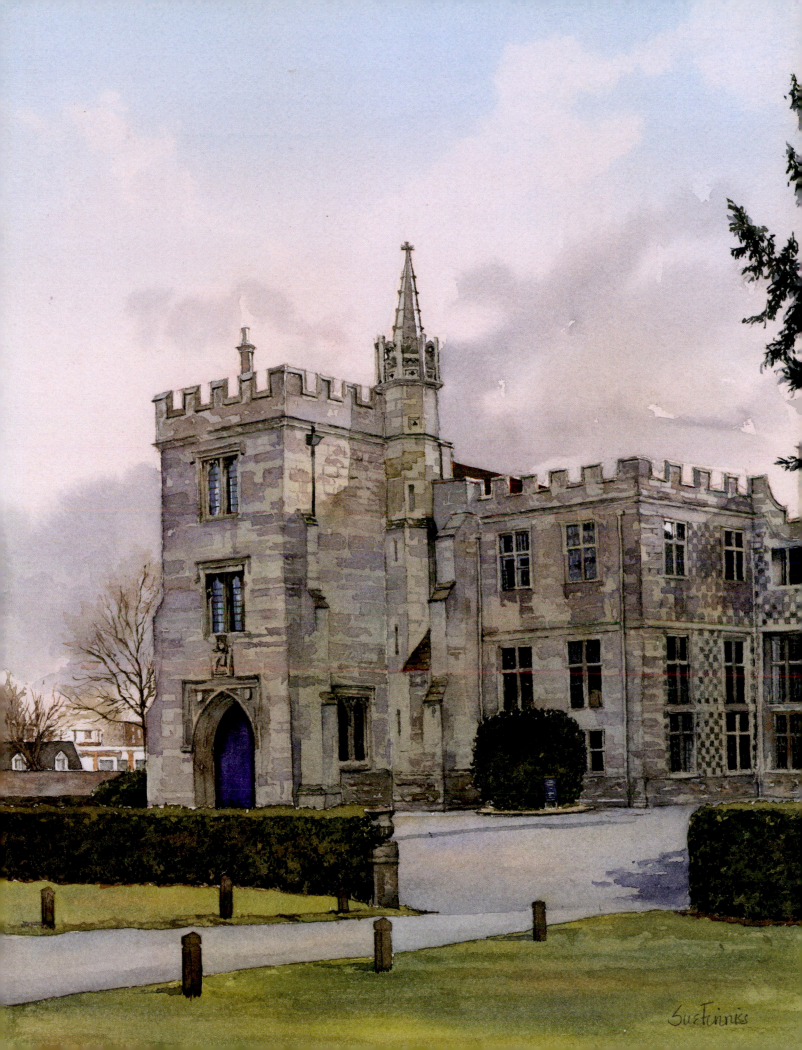

Sue Finniss

John Constable's view [15]

This picture was painted from the same place in the Bishop's Garden (Cathedral School) as John Constable painted his Salisbury Cathedral from the Bishop's Garden *in 1826.*

In 1822, John Fisher, Bishop of Salisbury, commissioned John Constable to paint his version of this composition. In Constable's painting Fisher and his wife are visible at lower left. In July 1824, Fisher asked Constable to revise the painting and a new canvas was started. It appears that this was traced from the earlier painting, and that Constable then painted in the sky and opened up the foliage which arched over the south transept. The effect was to make the spire more dominant. This latter painting was unfinished at the time of Constable's death.

John Constable (1776-1837) was born in Suffolk, and is mostly known for his landscape paintings of Dedham Vale, and other places which are now known as "Constable Country". He was a friend of Archdeacon John Fisher who lived in Leadenhall and was the nephew of Bishop Fisher.

Constable's most famous paintings include *Dedham Vale* of 1802 and *The Hay Wain* of 1821. Although his paintings are now among the most popular and valuable in British art, he was never financially successful and did not become a member of the Establishment until he was elected to the Royal Academy at the age of 52. He sold more paintings in France than in his native England.

Constable also painted *Salisbury Cathedral from the Meadows*, and exhibited it at the Royal Academy in 1831. He continued working on it during 1833 and 1834. This was one of his last major landscapes, and demonstrates the culmination of his attempts to depict Salisbury and its cathedral. His *Salisbury Cathedral from the River* was painted around 1820. Here the cathedral is seen from the water meadows to the north-west, with the bridge over the River Avon on the right.

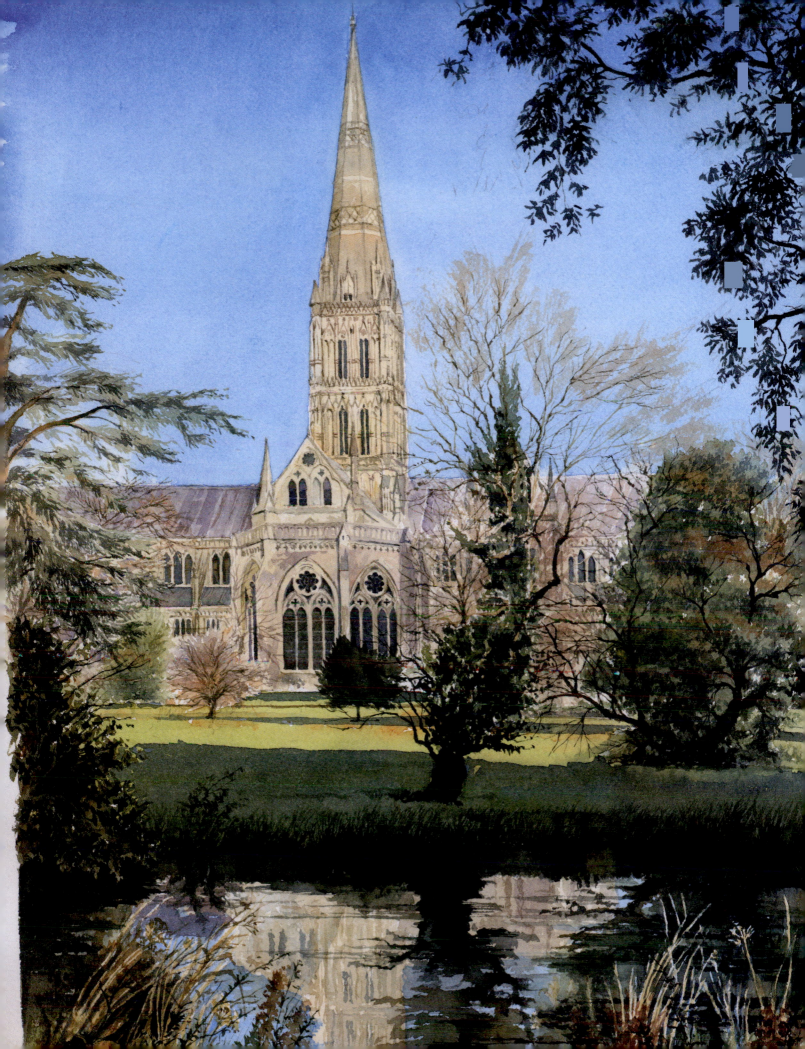

Gatekeeper's Lodge [16]

The Gatekeeper's Lodge is at the south-eastern corner of the Close, at the southern end of Bishop's Walk and at the entrance to the Cathedral School. This view was taken from inside the grounds of the Cathedral School looking north.

The Gatekeeper's Lodge was added in 1843. It was designed by T. H. Wyatt (1807–80), who was based in London but was quite prolific in Wiltshire.

It is a good example of the form of Gothic that became popular in the 1840s and 50s as part of what became known as the Gothic Revival; a sort of idealised reaction against the rapid modernization that was happening, and an attempt to go back to the values of an earlier medieval age.

The building is based upon the Gothic style which was used in the 13th and 14th centuries and in the cathedral. The architect would have been anxious to achieve as close a copy as possible of what might have been built in that period, though these ideas would have been updated to make use of the materials and equipment which were then available in the industrial mid-nineteenth century.

The building is constructed of ashlar stone which harmonises with the cathedral, though brick, a much cheaper material, was used in the less obvious areas.

Originally the Lodge had just a sitting room, bedroom and pantry with a small court to the east. By *c.*1890 the court had been converted to a kitchen with a bedroom over it, and the former pantry and passage had been converted to a further room.

Today the Lodge is used as an office.

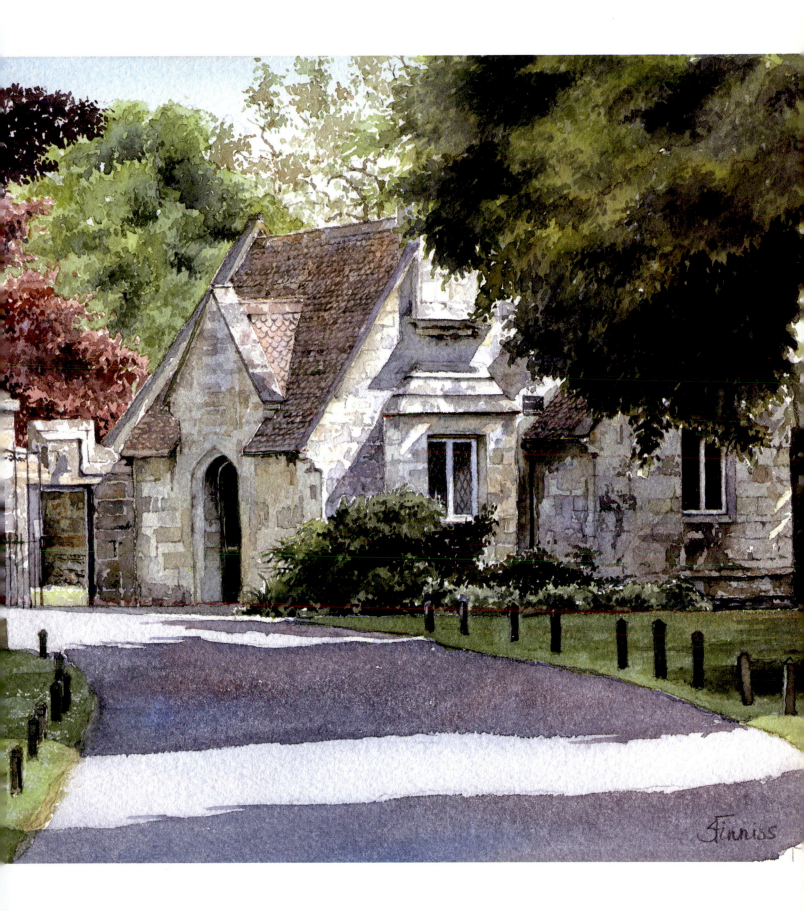

Sarum College [17]

The view is looking north along Bishop's Walk and shows the 17th-century and 19th-century parts of the college.

Sarum College is an ecumenical Christian education centre and comprises a red-brick building from around 1677 (the part straight ahead) and a mid-19th-century flint, stone and brick extension (a turret of which shows on the right).

The 1677 building was erected for Francis Hill who was the deputy recorder of Salisbury. Interestingly it occupies the northern end of Bishop's Walk with the old Bishop's Palace (now the Cathedral School) at the other end. Surely a clear sign of where the power lay in the 17th century.

Built of brick with a clay tile roof and prominent white windows, it is of nine bays, the outer two of which project, and has two storeys and hipped roofs.

The house remained in secular occupation until 1860 when Bishop Kerr Hamilton bought the lease and founded a theological college. An extension was designed by William Butterfield and built in two stages. There was student accommodation in a large L-shaped block at the rear, which was added 1873-5, and then a library and chapel at the front which were completed by 1878. The chapel is especially spectacular.

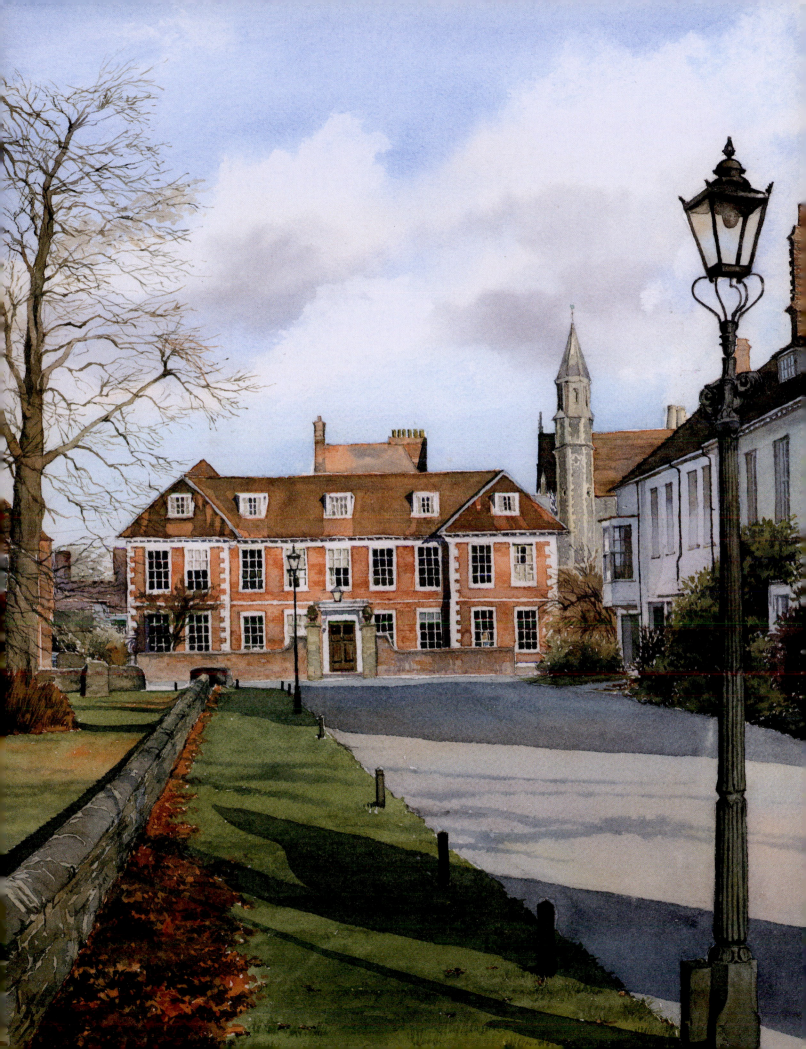

Walking Madonna & North Canonry [18]

This is a view across the Close, looking west. The North Canonry is in the distance.

Dame Elisabeth Frink (1930-93) was born in Suffolk and studied at the Guildford and Chelsea Schools of Art. She taught at the Chelsea and St Martin's Schools of Art and was a visiting lecturer at the Royal College of Art.

She was one of Britain's leading sculptors, received many honorary doctorates and was awarded the CBE in 1969 and made a Dame of the British Empire in 1982. Her main subjects were men and animals, the Walking Madonna being her only female depiction. Several have tried to identify the symbolism of the statue, viz:

'The Walking Madonna is a most potent symbol of resurrection – Elizabeth Frink's Walking Madonna, striding forth to bring Christ into the world – not as the teenage Virgin, pregnant with the new humanity, but an older Mary, stripped down, thin and ascetic, stomach hollow, face pinched and haggard with suffering – one who has been through the experience of the Pieta and held the dead body of her son across her knee, but now is determined and invigorated with resurrection life – "walking with purposeful compassion as a member of the community of the Risen Christ, to bring love where love is absent." May we tread in her steps, filled with light and love and joy, for the Dayspring from on high has visited us, and Christ is risen – Alleluia. Amen.' (*Salisbury Cathedral website*).

'There is only one female image in Frink's entire oeuvre, the compelling Walking Madonna in the Cathedral Close at Salisbury not far from her Dorset home. The figure was not intended as a self-portrait but when confronted with a commission for a female figure Frink involuntarily sculpted her own face. The work could be construed as a metaphor for the artist's life. This is no conventional, modest Madonna lurking in the security of a Cathedral alcove. She strides with singleness of purpose oblivious to the distractions of those around her. There is an integrity in her gaze, a sense of purpose and iron strength in her gaunt frame. Most importantly, she has turned her back on the sanctuary and security of the Cathedral. Choosing instead to stride out into the town to meet the world full on and grapple with the fundamental condition of mankind.' (*Elspeth Moncrieff*).

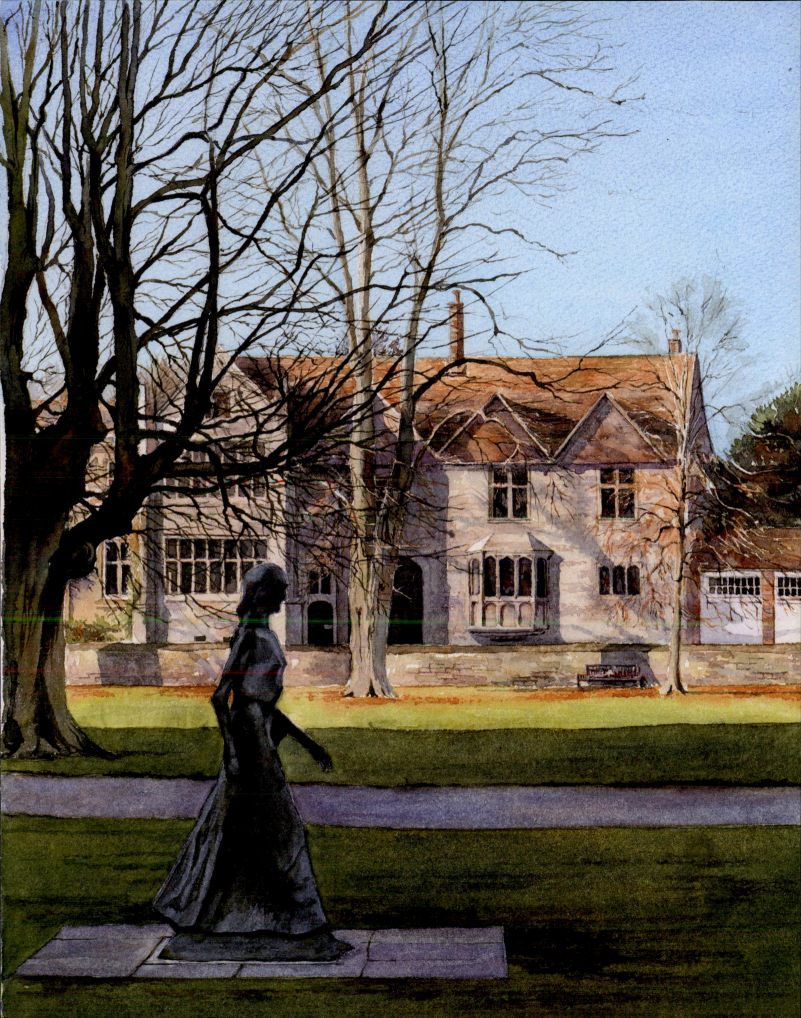

A View to the North [19]

This view looks north towards Choristers' Green and the North Gate.

In many ways this painting epitomises Salisbury, its differing elements and what makes it special for so many.

Adjacent to the city centre lies the cathedral and Close; havens of peace in a busy commercial world. Each year many thousands of visitors flock to Salisbury, just as did their predecessors, the medieval pilgrims. The cathedral is the venue for many of the large concerts which take place in the city while the Close is also the venue for the great closing concert and firework display that marks the end of the annual Salisbury International Arts Festival.

However, the cathedral and Close are more than a tourist attraction and a concert venue. They are also the spiritual and cultural heart of the city. The music tradition which is maintained by the cathedral authorities spawns a multitude of choirs and orchestras. Evening rehearsals occur on a regular basis and you can attend a concert or recital most weeks.

Salisbury is mostly known for its medieval heritage yet there are more Georgian buildings in the city than there are medieval ones. The red-brick building (part of Mompesson House) in the centre of the painting is not untypical.

The city lies beyond the Close and St Thomas's church stands proud above the North Gate in the painting. The old medieval street gridplan remains in the centre of the city, and you do not have to dig too deep to find much evidence of the medieval age.

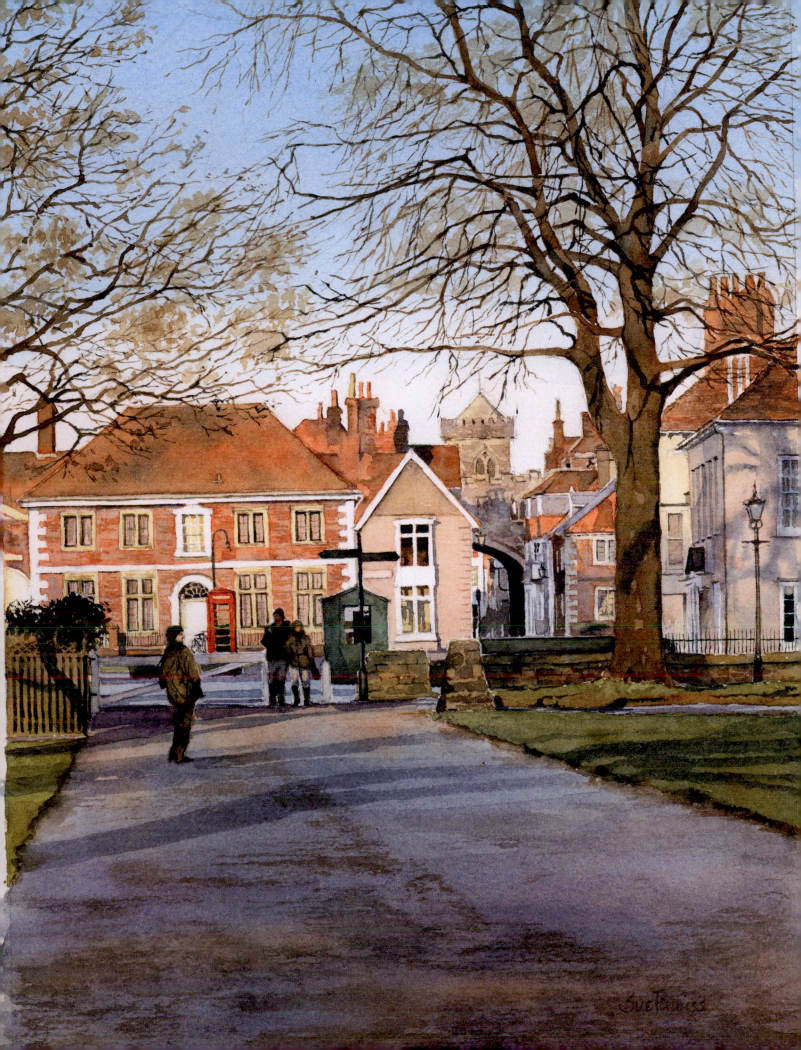

Sue Furniss

Tower & spire from the cloister [20]

This is a view of the tower and spire from within the Cloister.

When work on the cathedral was started in 1220 there were no plans to have a great tower and spire like that which exists today. However, by 1310 the plans had changed and a design emerged for a much grander building with a lofty spire that would reach to 404 feet (123 meters).

It is interesting to speculate why the original plans were changed so drastically. Clearly the original design would have been impressive, but Salisbury's spire is its crowning glory. Just as today the city needs the tourists and the money they bring, so also the medieval cathedral needed a regular stream of pilgrims. There were alternative sites of pilgrimage at Exeter, Wells and Winchester, and Salisbury needed to stake its claim to be the premier cathedral.

The erection of a stone two-storey tower and a massive stone spire on top of the existing building caused considerable structural strains. As early as the mid-15th century Bishop Beauchamp arranged for two strainer arches to be built. Then in 1668 Christopher Wren surveyed the cathedral and criticised the inadequate foundations and buttressing. He recommended changes, including the addition of bracing. Finally G.G. Scott added four scissor-braces within the tower, and these have ensured that there have been no further structural problems.

Those who would like to inspect these structural works, and to climb to the base of the spire, can do so. The cathedral holds regular tower tours which can be booked at the donations desk.

The spire at Salisbury is taller than that on any other English cathedral, and of most continental ones, though it is beaten by that at Ulm which reaches 530 ft, though this was not completed until the 19th century.

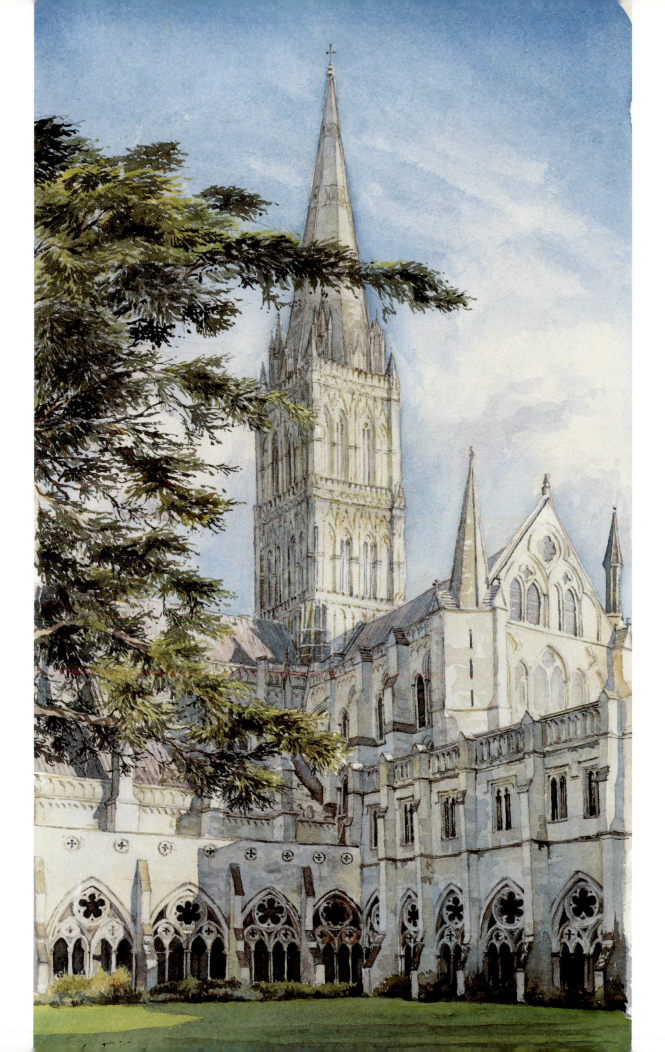

Cloisters [21]

Salisbury is a secular, rather than a monastic, cathedral. As such it needed a chapter house but not a cloister, which was probably added as something of an afterthought. It stands largely separated from the cathedral, so much so that a modern refectory has been constructed in the space between the cloister and the south aisle of the cathedral.

Construction of the cloisters started around 1240-50, and continued during the construction of the cathedral, but was completed before the spire and tower were built. There are twelve bays on each side and the arrangement emphasises width, making the whole appear much bigger and more spacious than it is.

The tracery of the openings is important, being copied from Westminster Abbey, where the designs were used in 1245-55, which in turn had copied them from Amiens Cathedral where they were used in 1235-40.

The area enclosed by the cloisters is lawned and has two magnificent cedar of Lebanon trees.

Today the cloisters continue to provide an area of relative peace and shade, while the northern side is now used as an overflow to the refectory, and as the site of a model of Old Sarum.

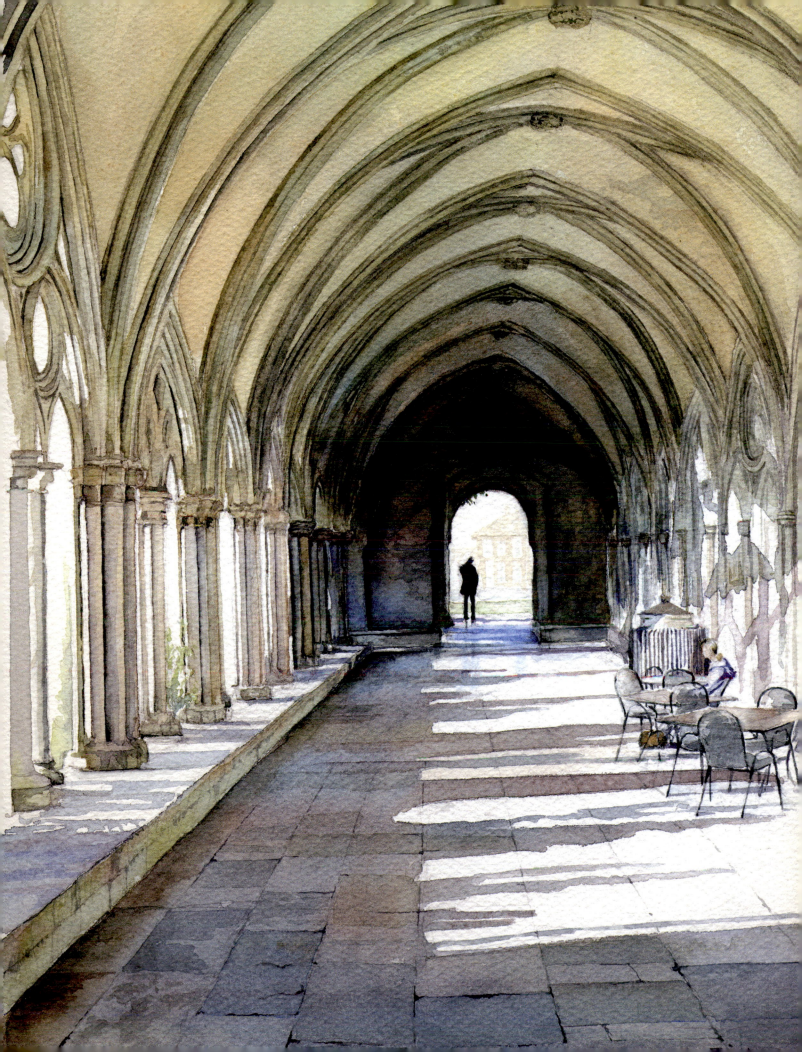

King's House [22]

Located on the West Walk, the King's House has had a varied history, and is now the Salisbury & South Wiltshire Museum. The museum is open Monday to Saturday from 10 am till 5 pm. It is also open on Sundays in the summer. The phone number is 01722 332151.

Originally called Sherborne Place, the King's House is mostly of the 15th to 17th centuries. It is named after James I who was entertained there by Thomas Sadler in 1610 and 1613. Before 1539 the house that stood here was the abbot of Sherborne's prebendal residence in Salisbury.

The 15th-century part of the building is on the left and comprised the two-storey entrance porch and a single long range behind with one gable on the left and two on the right. Inside there was almost certainly a great hall surrounded by various other rooms including a great chamber and an abbott's parlour and chamber.

This structure was extended to the north in the 16th and 17th centuries when the extension to the east was also built. Further alterations and renovations followed in the 18th and 19th centuries, and in 1899 a chapel was added at the rear which now acts as a lecture hall. Further minor extensions followed in 1965.

Various tenants have held the lease of the King's House, including the Godolphin School who occupied part of the building between 1836 and 1848. Then in 1849 the Diocesan Board of Education made a number of changes to the house prior to opening the Diocesan Training College for Schoolmistresses (which became the College of Sarum St Michael). Then in 1979, after the college had closed, the King's House was acquired by the Salisbury & South Wiltshire Museum.

Nos 72 & 73 the Close [23]

These two houses are located in the far south-eastern corner of the Close adjacent to the Harnham Gate.

The left-hand house - No. 72 - was built around 1754 as a home for one of the lay vicars. It has been changed slightly since then.

Its neighbour was built by a local gunsmith, William Lambert, between 1713 and 1721. Again some changes have been made since.

Both houses are mostly of brick with some squared rubble and tile hanging. They present a particularly picturesque scene at this corner of the Close.

Sue Frauss

Harnham Gate [24]

The gateway is located at the south-east corner of the Close and gives one-way access to De Vaux Place and then St Nicholas' Road. The gate is closed every evening until the following morning.

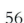

The gate dates from the middle of the 14th century, though it has been much modified. It was most probably originally connected to a walkway that extended around the Close wall and was topped by crenellations. It is built of ashlar blocks. The existing gates date from the 19th century.

The house is no. 74 the Close and is an 18th-century building. While the entrance to the house is within the Close the majority of it and its surrounding ground lies beyond the Close wall.

It was built *c.*1769 by Prebendary John Chaffey as a house for one of the lay vicars. In exchange for the house Chaffey took posession of the lay vicar's old house, no. 36, which is on the corner of the North Walk and the entrance through the North Gate. The necessary land was taken from the garden of an adjacent house in De Vaux Place which the Chapter owned.

The style is a simple mix of ashlar stone, rubble and brick with a clay tiled roof. It abuts the gateway and one of the 14th-century gargoyles from the gateway is located within the roof space of no. 74.

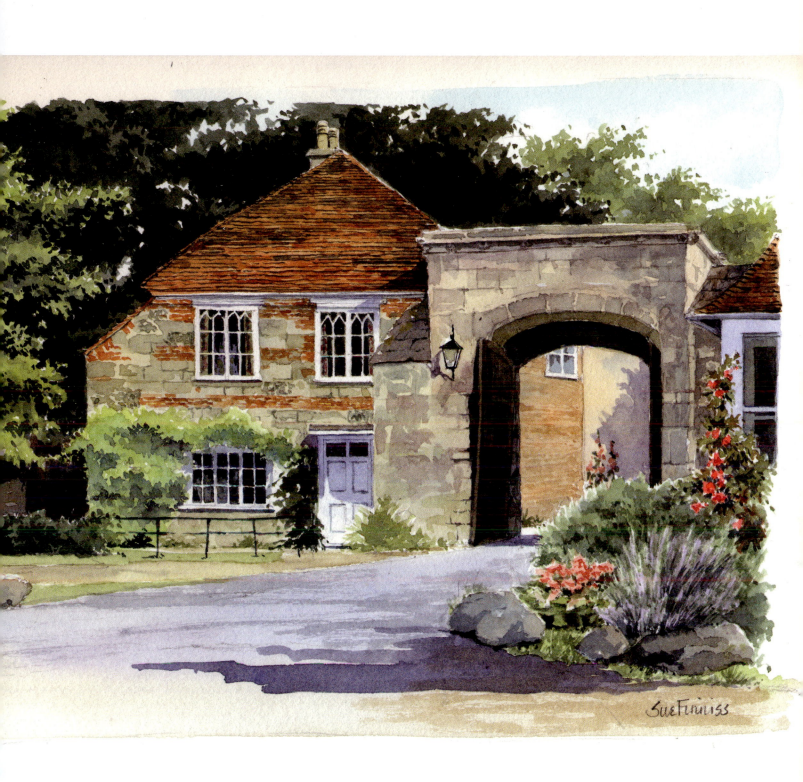

South Canonry [25]

Located in the far south-west corner of the Close this is now the bishop's residence. Like all the properties on the western side of the Close it has gardens that back onto the river and provide magnificent views across the water-meadows. The gardens are regularly open to the public.

This was originally the site of one of the more prestigious medieval canonries though the current house mostly dates from the 1890s.

All that really remains of the original house is a section of wall and a doorway in the cellar of the current house, though this building is well documented and was a very substantial dwelling with a chapel and a range of outhouses. Much of the original structure was demolished around 1648, and rebuilt about 1665-72. Offices were added in 1711 and the gatehouse taken down. More alterations followed in 1749 when the current east front was built with further changes in 1760 and 1789.

Then in 1890 much of the building was demolished and rebuilt behind the east facade to the designs of G.R. Crickmay, an architect who initially practiced from Weymouth but relocated to London where he was when this work was undertaken.

The eastern facade is very Georgian in appearance, with its balanced symmetry of four widely spaced bays which are gathered around a projecting central bay. Elsewhere the style is more Victorian, or specifically late-Victorian.

The house became the bishop's residence in 1951.

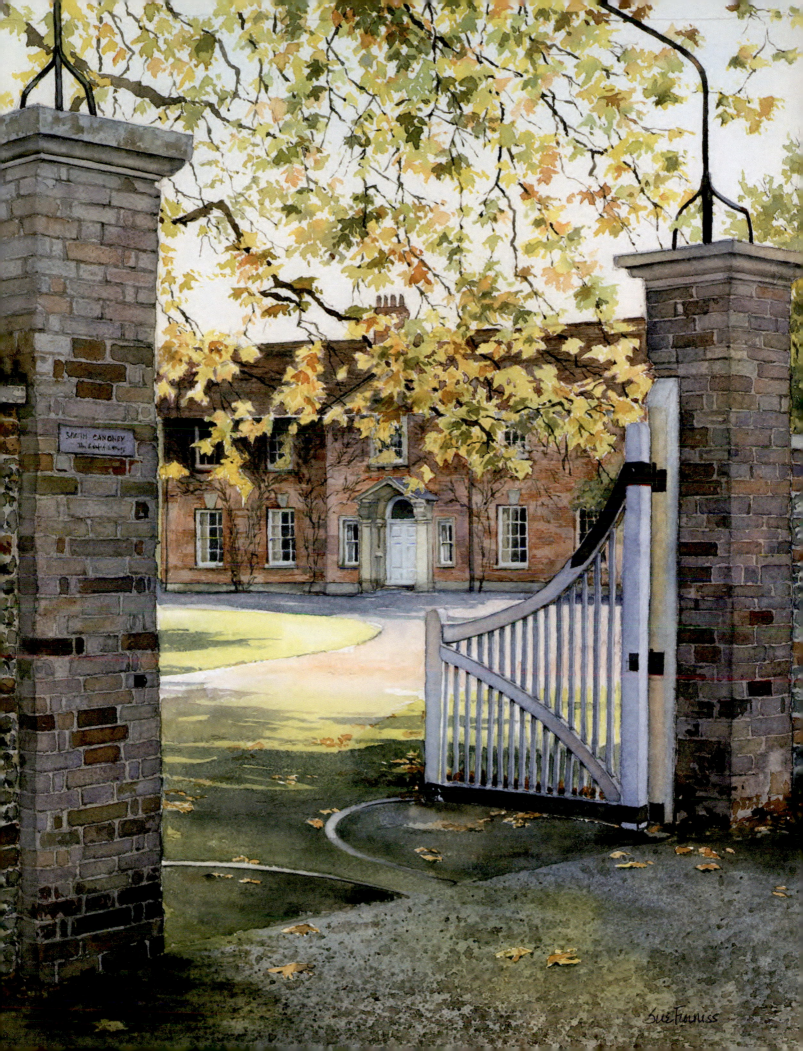

Leadenhall [26]

Located towards the southern end of the West Walk, the Leadenhall is now a private girls' school.

Originally the site of one of the very first medieval canonries, which was built here in about 1220, this was the home of Elias de Dereham, the man responsible for building the cathedral, though what stands today is mostly from the 1720s and the early 19th century.

Surviving documentation suggests that Elias de Dereham built the original canonry as an example which others could follow. It almost certainly comprised a great hall, chapel and domestic rooms. Its name also suggests that it may have had a lead roof; if so, this would have made it unusual.

Like most of the other houses in the Close, extensions, part demolitions and changes followed over the centuries until, in 1715 the cathedral treasurer sought permission to demolish the old house and build a new one, resplendent with stucco and Gothic detailing. Part of this building was demolished in 1915. The garden backs onto the river with spectacular views across the water-meadows.

In the early 19th century the house was occupied by Archdeacon John Fisher who was a friend of John Constable. It was while staying with Fisher that Constable undertook his several paintings of Salisbury Cathedral.

Today the building has a new and very active life, as an independent preparatory school for girls.

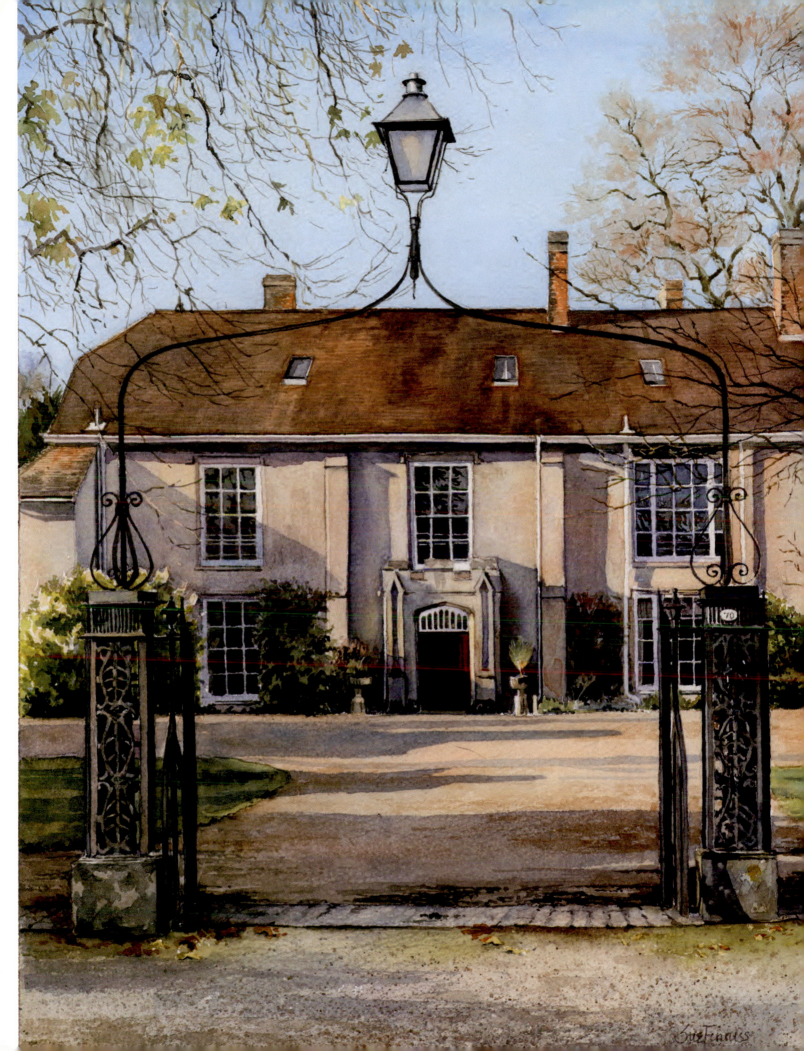

The Close [27]

This picture was painted looking north along the West Walk. The entrance to the Salisbury and South Wiltshire Museum is on the immediate left with Audley House in the distance.

The Close at Salisbury is the finest in England, with wide open expanses quite unlike that experienced at Winchester, Wells or Exeter. At Salisbury you also get two Closes, the main one which is predominantly to the west and north of the cathedral, but also Choristers' Green, a sort of minor Close, which is at the north-west corner and adjacent to the North Gate. At 83 acres, the major scale of Salisbury's Close makes it very special and a testament to the vision of its 13th-century creators.

The building of houses for the canons, choristers and other cathedral staff started at the same time as the cathedral was being built and many of the buildings still retain fragments of the original structures. The first record of a house was that intended for the bishop (now the Cathedral School), which was started in 1218. Many of the houses in the Close are still occupied by those who are connected with the cathedral and most of those which are not, are held on leases from the Dean and Chapter.

The building of a wall to enclose the cathedral and Close was authorised by Edward III in 1327 and this bounds the east, north and part of the south, leaving the River Avon to enclose the rest.

There are four gates into the Close - the North Gate which connects with the High Street, St Ann's Gate which connects with Exeter Street, Harnham Gate and another through the Cathedral School. These are closed each evening when the Close is cut off from the rest of Salisbury.

Originally the main Close to the north and west of the cathedral was a graveyard, but it was remodelled, levelled and grassed over by Bishop Barrington and James Wyatt towards the end of the 18th century. A separate bell-tower existed to the north of the western end of the cathedral, and this was demolished at the same time. While some may regret such acts, the openness and greenness of Salisbury's Close is what makes it so special.

In 1782 Lord Torrington wrote that 'the close is comfortable and the divines well seated'. So are today's residents.

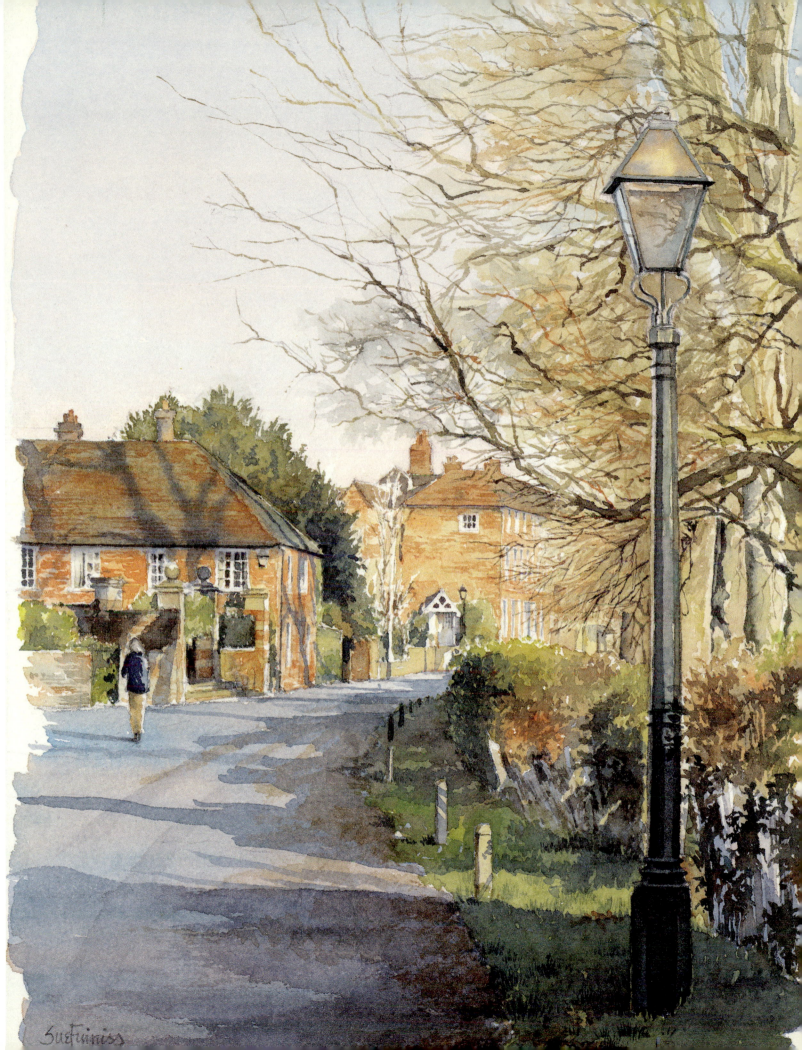

Sue Furniss

Walton Canonry [28]

This substantial house is located on the West Walk and backs onto the river Avon.

This is one of the finest buildings in the Close. It dates from about 1720, and was probably built by Canon Eyre to replace an earlier building. The house is named after Canon Isaac Walton who lived here before Eyre, and was the son of Izaac Walton, author of *The Compleat Angler* and biographer of George Herbert.

In 1938 the house was leased to the artist Rex Whistler. He was killed in the D–Day landings in Normandy and his brother Laurence designed, as a memorial, the beautiful crystal prism which can be seen in the Morning Chapel of the cathedral.

The house has seven bays, two storeys and a basement, and the whole is of brick. An elegant parapet hides the roof and the elevated ground floor and steps present a grand 18th-century view of life, with the fortunate elevated above those who were less so.

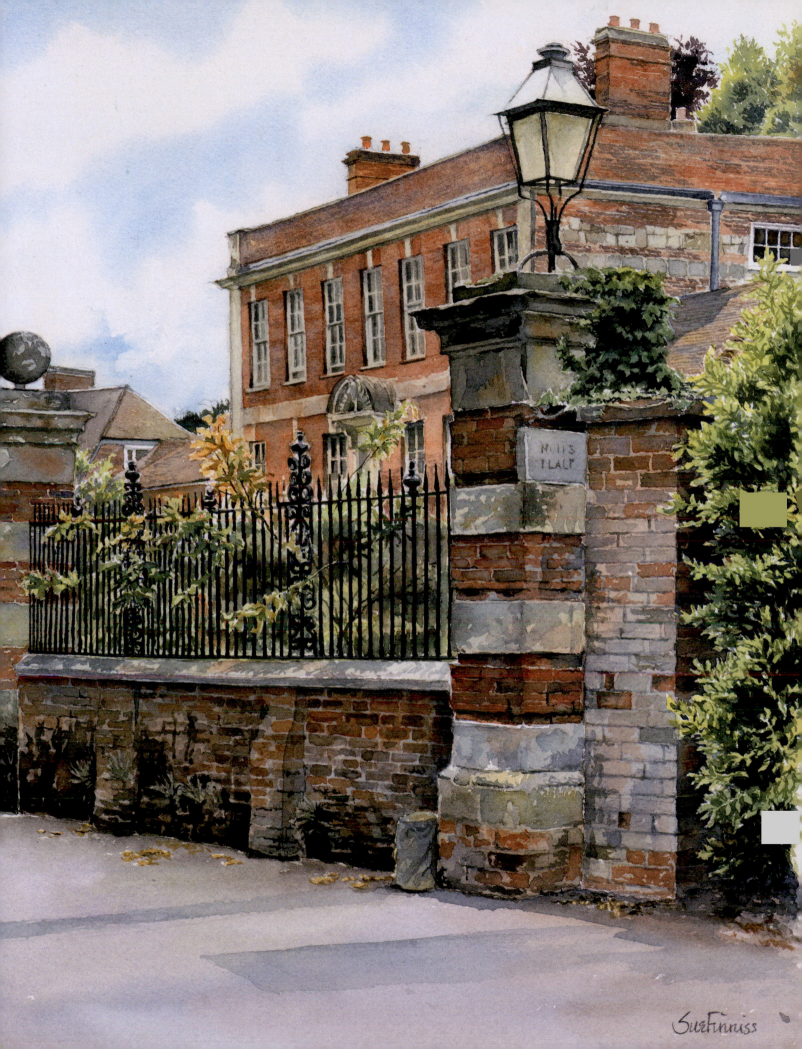

SueFinniss

Myles Place [29]

Next door to the Walton Canonry and also backing onto the Avon.

This is another exceptional house. A medieval canonry originally stood on this site but the current four-storey house dates from 1718 and was built by William Swanton who came from a legal family and was the town clerk of Salisbury in 1704. The house then passed to a doctor from the local infirmary and has remained in secular occupation ever since.

The house is a real mix of styles. The eastern front is of ashlar stone and is divided into three central bays supported by two two-bay wings. There is a basement and an attic floor, though the principal floors are between these, and a Doric entablature is supported by giant Doric pilasters. The doorway is enclosed by Corinthian pilasters and is topped by a pediment and shield-of-arms.

The house comprises four ranges which are gathered in a box formation. The rear face is of brick but its arrangement of windows mirrors the eastern front. The sides are mostly tile hung.

On the ground floor there is a drawing room, dining room, kitchen, a grand staircase and a library which runs from front to back. The style is elegance itself, with much timber panelling and plaster decoration.

Sir Arthur Bryant, the historian, lived here for many years until his death in 1985.

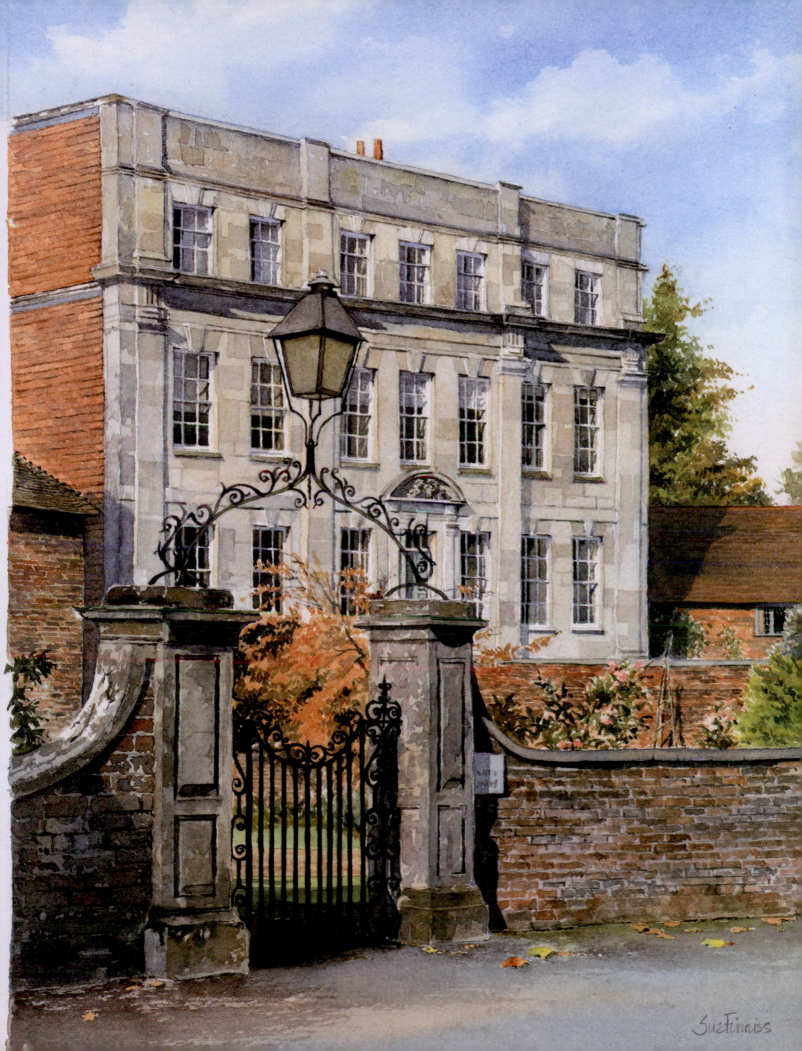

SueFinniss

The cathedral from the west [30]

This painting shows the western end of the cathedral plus the tower and spire from just in front of the Salisbury & South Wiltshire Museum - the King's House - which is located off the West Walk.

The west front was most probably largely constructed between early in the 1230s, and was completed by 1266, though at this stage it may have been without the many statues that were intended to decorate it.

Today many of the niches are empty, and many of the statues that remain are either Victorian or more recent carvings; such is the effect of aerial pollution which ravages the stone.

The cathedral is dedicated to the Blessed Virgin Mary and above the great western door there is a depiction of the Virgin and Child surrounded by censing angels. This whole area was important liturgically, and especially at Easter. It was lavishly decorated with vibrant colour, traces of which can still be seen, particularly in the porch.

Either side of the great west window of three lights there are statues of the four Gospel writers: Matthew above Mark on the north and John above Luke on the south. Framing these depictions are four statues, Abraham above St Peter on the north and Noah above St Paul on the south, each shown with his attributes of knife, keys, ark and sword.

In the space between the porch and the window there are thirteen statues which are arranged in a line, starting with John the Evangelist on the north, St George sixth from the north and St John the Baptist on the south. At the very top of the central gable we can see Christ in Majesty below the eagle of St John.

Outside this central area, each level of the facade has further depictions. At the top there are angels and archangels, then Old Testament prophets, with New Testament prophets below that, and interspersed in the bottom row with local worthies like Bishops Poore and Osmund.

In front of the facade there is an interpretation board which shows the identity of the various statues. There is also a leaflet available in the cathedral shop, and the book *Salisbury Cathedral: The West Front* provides a comprehensive history and description.

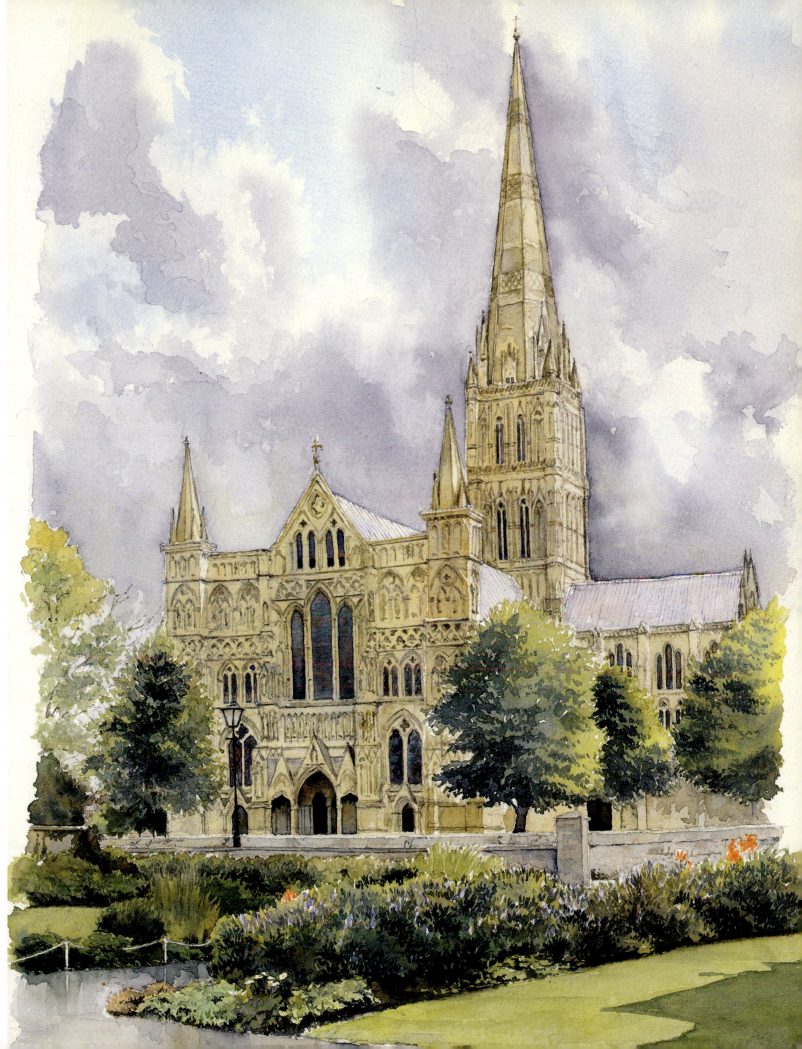

Medieval Hall (The Old Deanery) [31]

Many fail to discover this fine building which is well-hidden amongst much more recent structures on the western side of the Close, almost opposite the western end of the cathedral. There are signs which lead the way.

The western side of the Close was dominated by a teachers' training college for much of the 20th century. Numerous new buildings were erected between the West Walk and the river, that engulfed the medieval hall which was almost demolished in 1959 before it was discovered that much of the 13th-century house still existed behind the 19th-century facade. Today the training college is no more, much of the new building has been converted to domestic use and the medieval hall has been restored.

This was originally the site of a canonry which was built around 1258 and became the deanery in 1277. There is evidence of periodic extension and development which seems to align with periods of occupation by different deans and especially in the late 14th and early 15th centuries.

The effect of all the changes was to create a very significant complex of buildings which comprised a great chamber, or hall, a tower and a range of domestic rooms. Much was demolished, especially in the 19th century before what remained of the building was reordered in the mid-20th century. The flint and stone exterior was repaired and the great hall restored and given a new lease of life.

Today the hall is privately owned and used for functions.

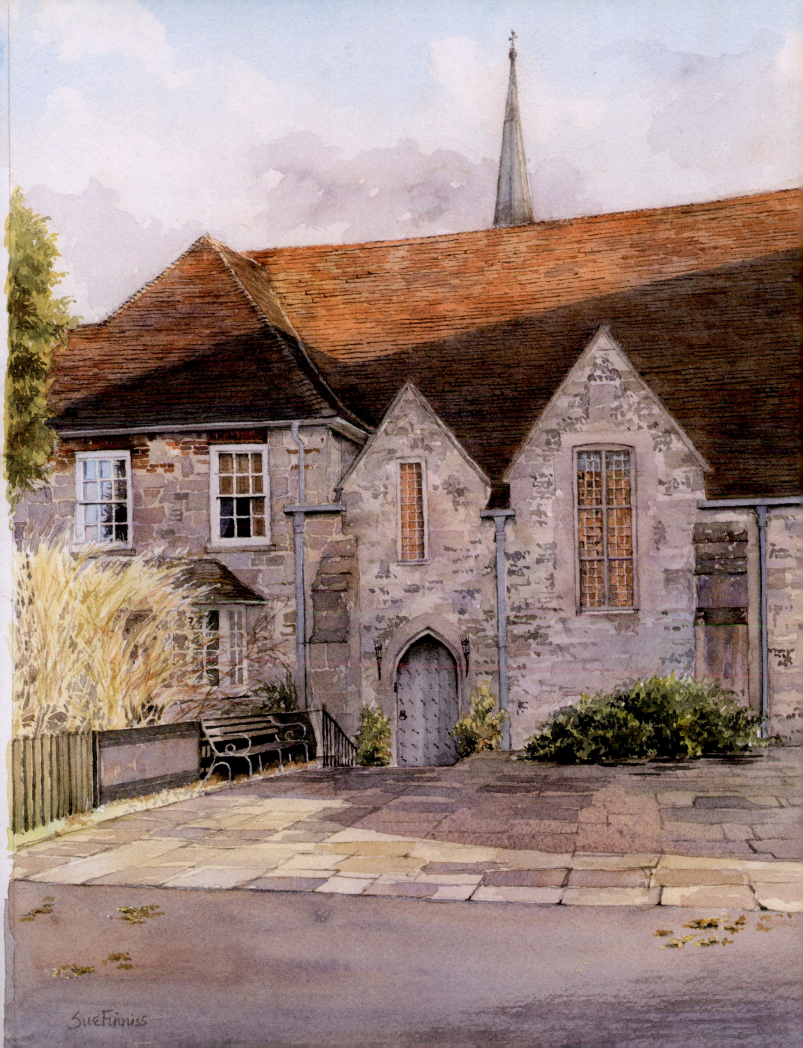
Sue Finniss

Arundells, 59 the Close [32]

Formerly the residence of Sir Edward Heath, KG, MBE prime minister 1970-74, leader of the Conservative Party 1965-75. Best remembered for being the prime minister who took Britain into the European Economic Community.

This was originally a 13th-century canonry, and the cross-wing of the medieval house still forms the core of the current building which has been altered and extended many times. The different phases of building are clearly visible on the rear elevation. The last canon, Leonard Bilson, lived here in 1562, until he was deprived of his canonry for practising magic. It then passed to secular tenants and has remained so ever since.

The current house, whose elegant frontage is typically Georgian, is largely the result of work by John Wyndham who held the lease from 1718-50. The house name commemorates James Everard Arundell, the 6th son of Lord Arundell, who married Wyndham's daughter Anne in 1752 and retained the tenancy until 1803. As a staunch Roman Catholic he reputedly accommodated Jesuit priests at the house for some years.

From 1821 the house became the Godolphin School, and from 1839 to 1844 it was a boys' school with boarders. Later it fell into decay before being renovated in 1964. Sir Edward Heath lived there from 1985 until his death in 2005 acquiring the freehold during that time. The house became famous for its visitors and grand lunch parties.

Today the house and grounds are open to the public between March and September, but pre-booking is advisable (01722 326546). Edward Heath's collections of musical instruments and sailing memorabilia are on display along with Oriental and European ceramics, paintings which are mainly by British artists, including two painted and given to Sir Edward by Sir Winston Churchill.

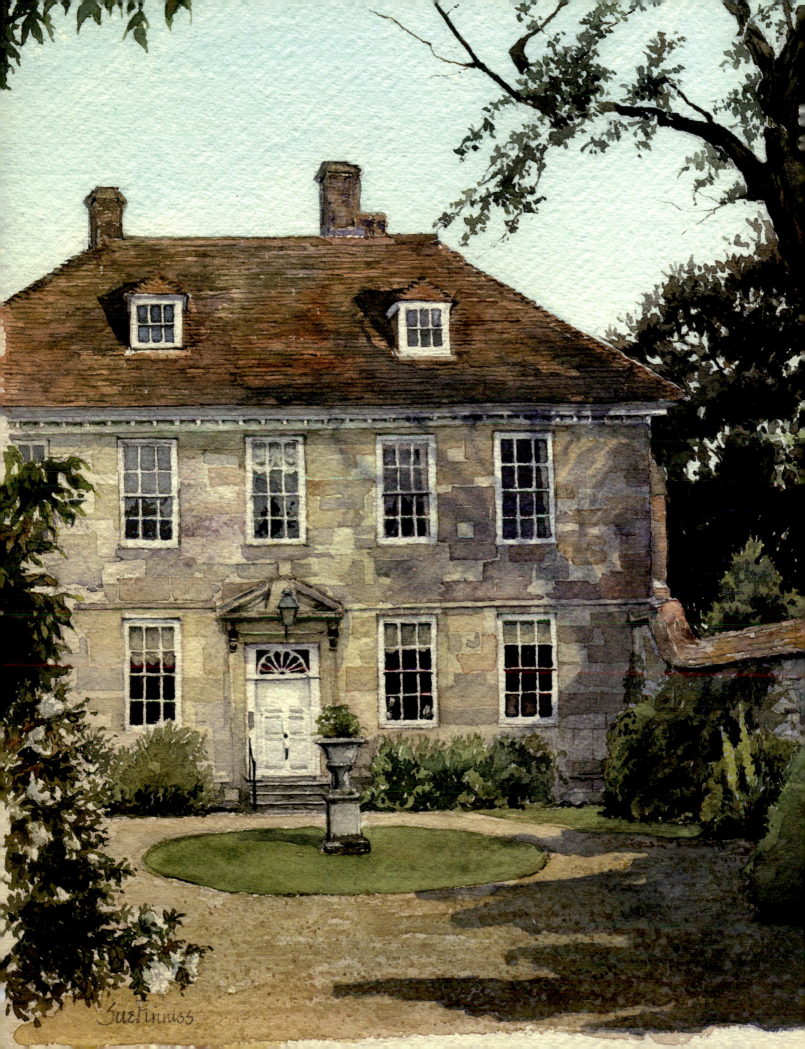

Wardrobe [33]

This is now the Rifles (Berkshire and Wiltshire) Museum and is located at the south-western corner of Choristers' Green. For visitor details contact 01722 419419 or www.thewardrobe.org.uk

Originally this was another medieval canonry which was in the gift of the bishop. It was presented to Walter Scammel in 1277. It probably fell out of use as a canonry in the 14th or 15th century.

Substantial alterations were made after 1588, and further changes were made between 1762 and 1776. A gatehouse was demolished in 1807. In 1831 it was advertised with a breakfast room, dining room, billiard room or library, plus 8 bedrooms with space for 4 more.

For many years the house was an annex to the training college before it became empty. It was restored in 1979 and became the museum of the Duke of Edinburgh's Royal Regiment.

The exterior is an interesting mix of flint, brick and stone, all of which are used in an irregular fashion. The eastern facade has a recessed centre with two projecting wings, each with two gables. The rooms in the roof, which have superb views of the cathedral, are rented out by the Landmark Trust.

There is a fine garden which backs onto the river.

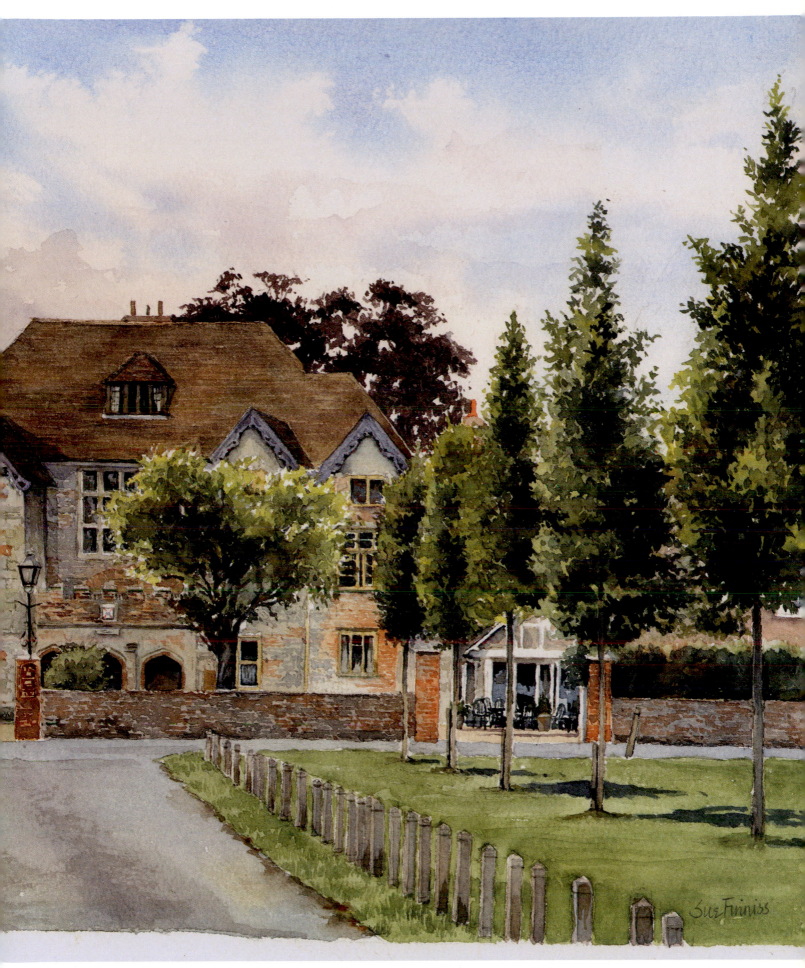

Corner of Choristers' Green [35]

This view looks into the far north-western corner of Choristers' Green.

The house on the right - no. 55 - dates mainly from the 18th century, but, like so many other houses in the Close, incorporated the remains of an earlier building.

In 1618-19 it was held by the vicars choral and in 1649-50 it was described as a 'tenement with a hovel'. The lease was acquired by Edward, Duke of Winterbourne Stoke in 1661 and by 1674 the house had been mostly rebuilt. A further rebuilding occurred in the 1720s and the result is the building we see today.

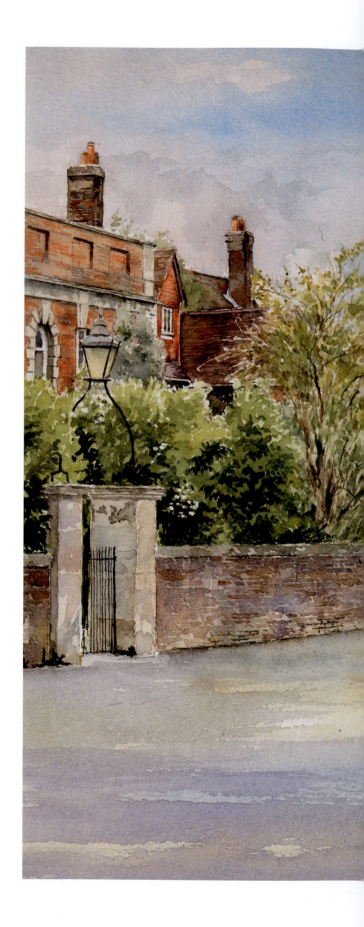

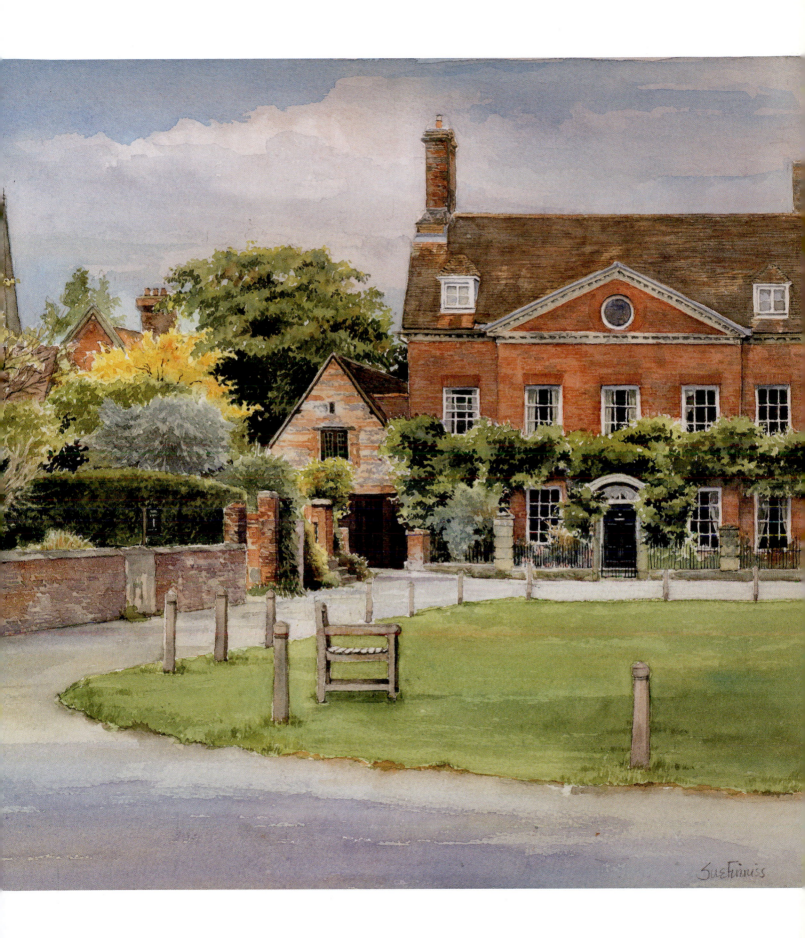

Wren Hall [36]

One of a series of buildings on the western side of Choristers' Green. Today it is used as the Diocesan Education Centre.

The existing building was completed in 1714 as the choristers' schoolroom and comprises a large schoolroom which is elevated on a mezzanine level and entered by a series of steps. Prior to that this was part of the site of William Braybrooke's medieval canonry.

As originally planned the schoolroom would have been connected internally to the master's house (Braybrooke) which abuts it on the south, and both are raised above a basement. The Wren Hall is of five bays, built of brick with stone dressings below a tiled hipped roof with gabled dormers. Internally the large schoolroom is part panelled and had the headmaster's seat at the south end with the assistant master at the north.

The grammar school had existed within the Braybrooke canonry from as early as 1559 and 'no fit boy' should be refused. Wren Hall, being a significant new facility, provided a classroom and further dormitories for the choristers. In 1947 it passed to the teachers' training college, then housed the diocesan records, before taking on its current role.

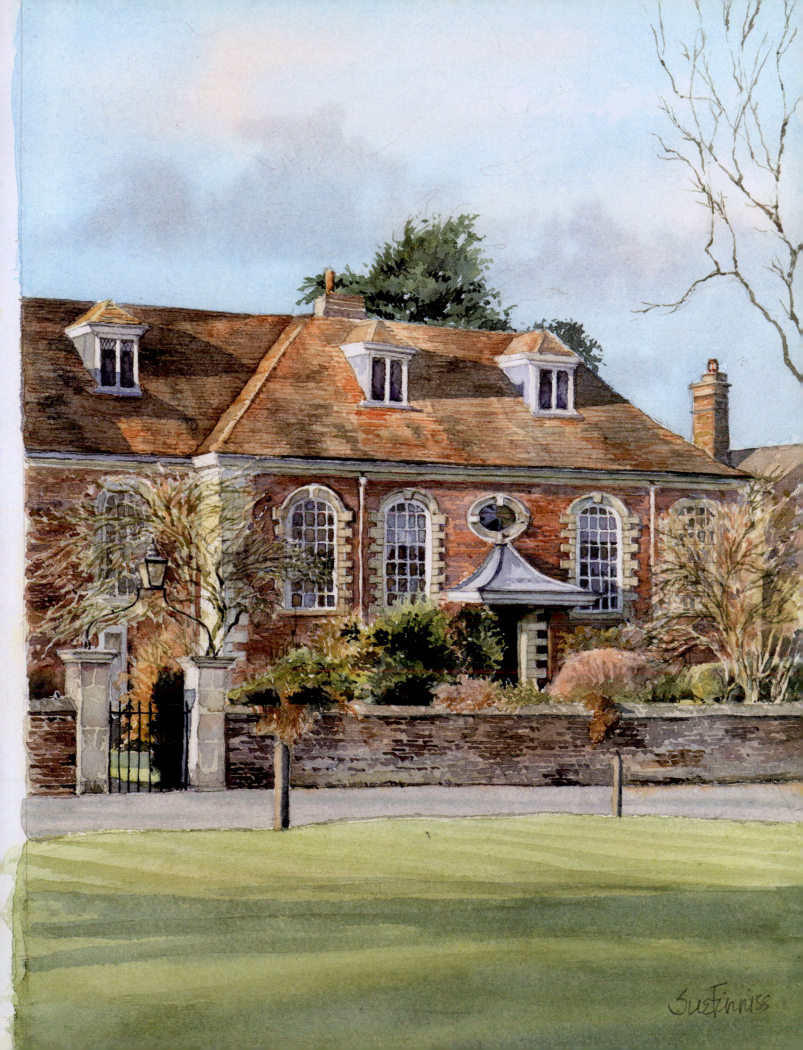

SueFinniss

56a & b, Hemingsby [37]

This delightful pair of houses is located in the top north-western corner of the Close and Choristers' Green.

Like many houses in the Close this was originally part of a much larger medieval canonry and remained so till 1649 when it was sold to the city who conveyed it to Rev. John Strickland, the minister of St Edmund's.

Little of the original building remains except for the early 14th-century porch (probably from 1334) and the 15th-century hall (probably from *c*.1450) built by Canon Fidian, a Greek scholar who escaped the siege of Constantinople in 1453, whose name is decoratively carved on the woodwork.

After 1649 the house was much altered; the chapel at the north end of the hall was pulled down and the hall subdivided. Further changes followed in 1727 when two big chambers were created from a number of smaller rooms. The house was subdivided into two properties in 1950.

The painting shows the projecting 14th-century porch on the right. The great hall then ran north/south behind this with parlours and bedrooms beyond this again. The whole is an exquisite combination of ashlar stone, flint and brick with a clay tile roof. It is set in one of the quietest corners of the Close.

Today both houses are in private occupation.

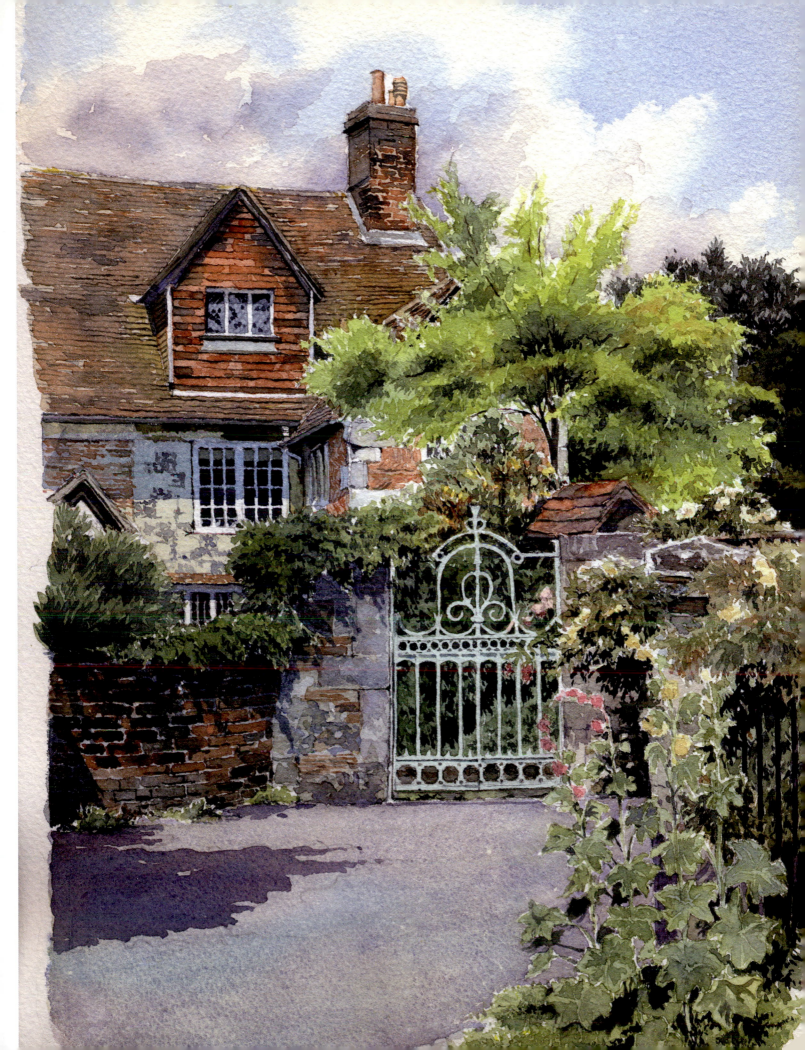

Mompesson House [38]

Located on the north of Choristers' Green and owned by the National Trust. The house and garden are open every day except Thursday and Friday from mid-March to October. Telephone 01722 420980 for details.

This is one of the finest houses in the Close and a good example of the style and fashion at the very start of the 18th century.

The date 1701 is shown on a rainwater-head and that fits with the style of this seven-bay house of ashlar stone below a tiled hipped roof. The focus is the slightly wider central bay and the doorway which is decorated with a giant pediment and garlands. The entrance front is also enhanced by the elegant ironwork and gateway. The other facades are of brick and there is a brick extension to the north. The house was built by Charles Mompesson, and forty years later, his brother-in-law, Charles Longueville was responsible for the fine stucco, splendid plasterwork ceilings and grand staircase.

At the rear there is a very pleasant enclosed garden which catches the sun but not the wind! There is a service range on the east. The old stables date from the same time as the house, while the other buildings are from the mid-18th century.

The Townsend family lived in Mompesson House from 1846-1939, Barbara Townsend lived here the whole of her life until her death at 96. She was a legendary character in the Close and an accomplished amateur artist producing delicate watercolours, some of which can be seen inside.

The house was in secular occupation until 1939. It then became the bishop's residence from 1946-51, and in 1952 it was sold to Dennis Martineau who bequeathed it to the National Trust.

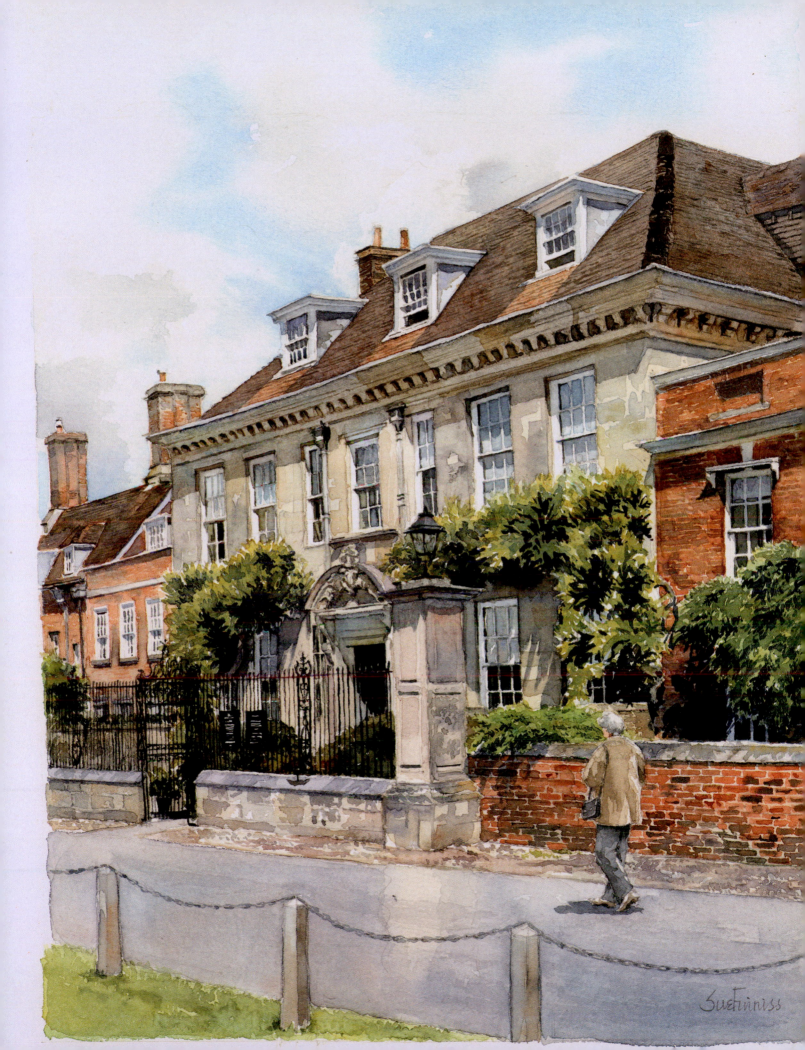

Sue Finniss

North Gate exit [40]

The North Gate opens onto the High Street of the city of New Sarum, or Salisbury, which was created at the same time as the cathedral, and remained under the control of the bishop until 1611.

By the end of the 13th century there were three parish churches in the city; St Thomas, which is at the northern end of the High Street, and was the church of the city merchants, St Edmund's to the north-east which was built to handle the city's expansion, and St Martin's which pre-dates New Sarum and is just outside the medieval city. The focus of the city was and still is the Market Square.

From the 15th century Salisbury had a flourishing cloth trade and some of the grander houses were the homes of the richest merchants. The original street plan is still recognisable, and though most of the houses have been changed and refaced several times, the medieval origins are often still visible.

Salisbury was famous for its water channels which ran through many of the streets. These were fed by the river Avon and initially provided fresh water but gradually fell into disrepair and misuse and were filled in during the 19th century in an attempt to eradicate outbreaks of cholera.

When Daniel Defoe published *A Tour through the whole Island of Great Britain* in 1724, he referred to Salisbury as 'indeed a large and pleasant city' which was 'full of a great variety of manufactures; and those some of the most considerable in England'.

The railway came to Salisbury in 1847, though the terminus was at Milford to the east of the city. The present station is from 1859, by which time the railway had been extended around the city to connect with the line which runs from Bath and the north. With the railway came the development of Fisherton to the west of the city.

In even more recent times Salisbury has expanded further, though nothing like as much as many other cities and towns. The main current problem is traffic, and the main perceived solution is a park and ride system.

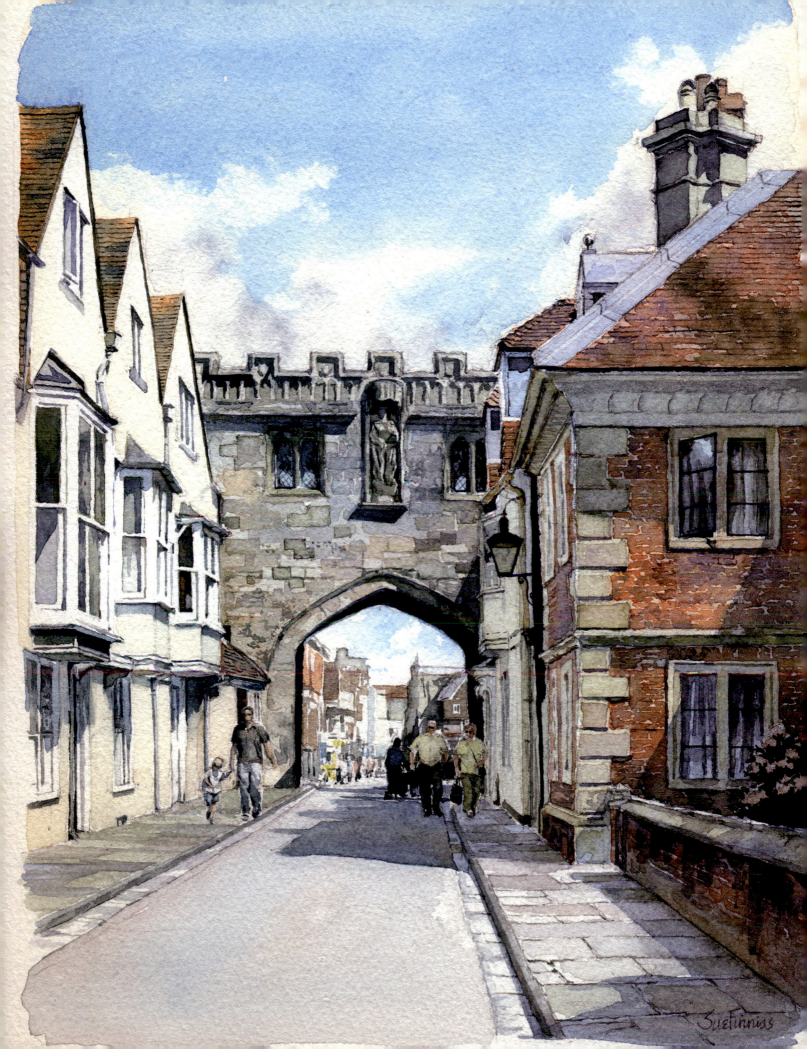

Sue Finniss

Some useful dates

The cathedral is built of Tisbury, Chilmark stone and embelished with Purbeck marble. It is 449 ft long (137 meters) and the top of the spire is 404 ft (123 meters) above the ground.

1075	Bishop's seat moved from Sherborne to Old Sarum
1078-92	Cathedral built at Old Sarum
1099	Bishop Osmund dies
1125	Cathedral at Old Sarum rebuilt and enlarged
1218	Papal licence granted for move of cathedral from Old to New Sarum
1220	Foundation stone of new cathedral laid on 28 April
1225	Consecration of three altars at the eastern end
1226	Reburial of three earlier bishops: Jocelin, Roger and Osmund
1236	Eastern part of cathedral completed
c.1240-60	Bell-tower built
1240-66	Cloisters and chapter house added
1258	Consecration of part-built cathedral
1265	West front completed
1266	Roof leading completed
1334	Work on the tower extension and spire started
1327	Licence granted to build the Close wall
1445	Library added above cloisters
1450	Strainer arches added to support tower and spire
1457	Bishop Osmund canonised
1624	Taverns and ale houses within the Close suppressed by the Dean and Chapter
1668	Christopher Wren surveys the cathedral
1789-92	James Wyatt undertakes major restoration work on cathedral, demolishes bell-tower and clears the graveyard
1823-34	John Constable paints cathedral scenes
1863-78	Cathedral restored by G.G. Scott
1947	Old Bishop's Palace becomes the Cathedral School
1949-51	Top part of spire rebuilt
1980	*Prisoner of Conscience* window installed at east end
1982	Elizabeth Frink's *Walking Madonna* installed
1991	First English cathedral girl choristers' choir formed

Glossary

Canon Clergyman belonging to cathedral chapter or collegiate church.

Canonry House or dwelling occupied by a canon.

Chapter House A building used for assemblies of those responsible for the business, administration and discipline of the cathedral.

Dean Head of the cathedral chapter.

Decorated The architectural style prevalent between *c.*1290 and *c.*1350.

Early English The architectural style prevalent between *c.*1180 and *c.*1290. Most of Salisbury cathedral was built at this time and is one of the greatest examples of 13th-century architecture, making much use of plain, un-cusped lancet windows.

Gargoyle A water spout which is decorated with carving depicting an animal or human head.

Gothic The architectural style of the late twelfth to the mid-sixteenth century, characterised by pointed arches, clustered piers, window tracery, pinnacles, spires and soaring verticality. Medieval builders had no such term for their work and it was invented later. Yet later again British writers subdivided it into Early English, Decorated and Perpendicular.

Lay Vicar Non-ordained member of the cathedral choir. Often also known as vicars choral when they are ordained clergymen.

Prebendary A clergyman who receives an allowance from a cathedral or collegiate church.

Strainer arch An arch which spans the space between two vertical bodies so as to transfer pressure or prevent a wall from bulging.

Sarum Rite The liturgy, music and management processes used at Salisbury cathedral during the medieval period and until the Reformation. It was adopted widely throughout the English church (see Philip Baxter, *Sarum Use: The ancient customs of Salisbury* (2008) for further details).

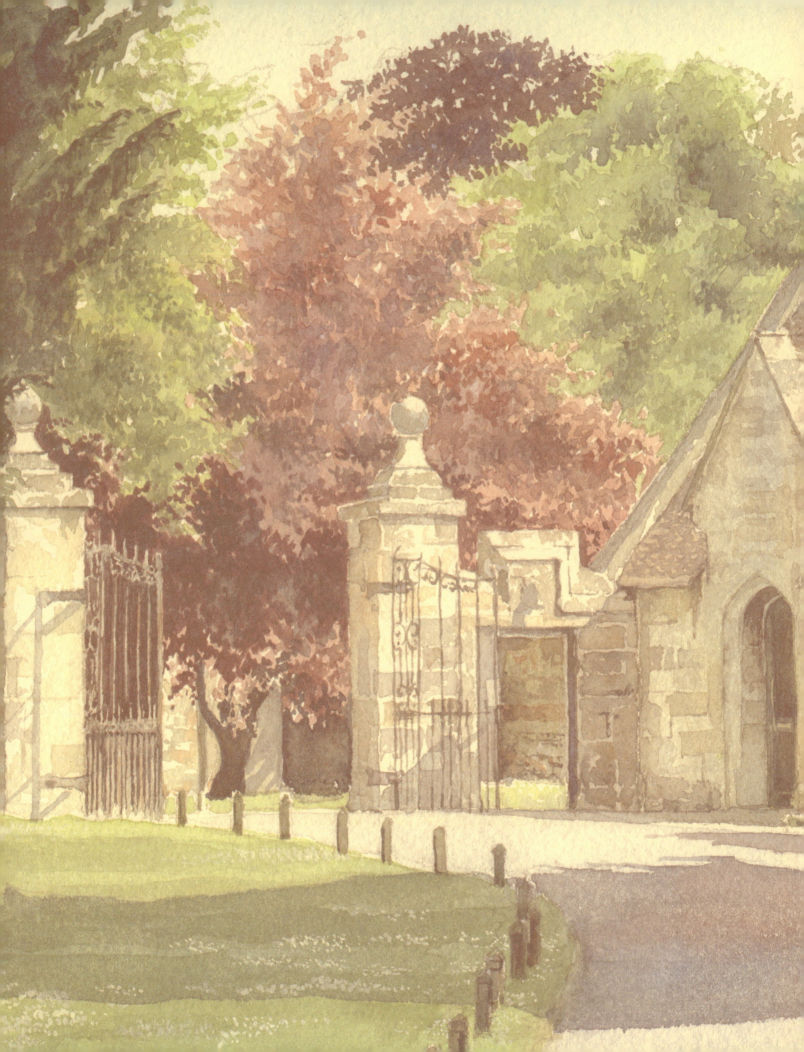